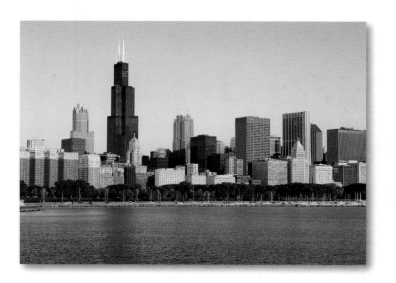

CHICAGO

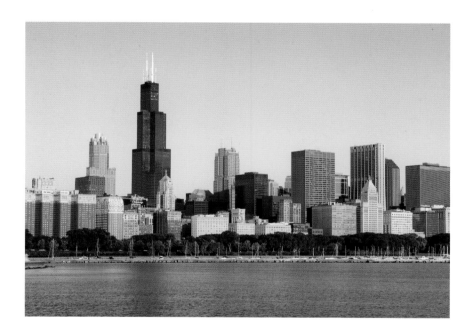

whitecap

The information in this book is true and complete to the best of the author's knowledge. All recommendations are made without guarantee on the part of the author or Whitecap Books Ltd. The author and publisher disclaim any liability in connection with the use of this information. For additional information please contact Whitecap Books Ltd., at 351 Lynn Avenue, North Vancouver, British Columbia, Canada V7J 2C4.

Text by Tanya Lloyd Kyi
Edited by Elaine Jones
Photo editing by Tanya Lloyd Kyi
Proofread by Kathy Evans
Cover and interior design by Steve Penner
Desktop publishing by Susan Greenshields
Front cover photograph by Walter Bibikow
Back cover photo by Kunio Owaki/First Light

Printed and bound in China

Library and Archives Canada Cataloguing in Publication

Lloyd, Tanya, 1973–

 Chicago

 ISBN 1-55285-026-9 (hardcover). — 1-55285-599-6 (paperback)

 ISBN 978-1-55285-026-8 (hardcover). — 978-1-55285-599-7 (paperback)

 1. Chicago (Ill.)—Pictorial works. I. Title.

F548.37.L56 2000 977.3'110434'0222 C00-910062-8

The publisher acknowledges the financial support of the Government of Canada through the Canada Book Fund (CBF) and the Province of British Columbia through the Book Publishing Tax Credit.

For more information on the America series and other Whitecap Books titles, please visit our website at www.whitecap.ca.

The summer had been hot and dry. Wooden buildings crowded together along the streets. It took only a tiny spark to set the entire city of Chicago on fire on the night of Sunday, October 8, 1871. A strong southwest wind fanned the flames, the city's usual warning system failed, and within hours downtown was ablaze. At midnight, the flames leapt the Chicago River. At 3:30 A.M. the roof of the water pumping station collapsed, ending fire-fighting efforts. Finally, on Tuesday morning, after more than 36 hours of destruction, rain tamed the blaze. When city workers began to assess the damage, they discovered that 2,000 acres had been destroyed. The Garden City of the West had become a blackened ruin.

In the history books, you might read of the first Europeans to visit this site, Father Jacques Marquette, a French missionary, and Louis Jolliet, an explorer and map maker, who arrived in 1673. A town was incorporated there in 1833 and five years later Chicago, by then home to more than 5,000 people, became a city. Within a few decades, it was a railway terminus and a business and political center. Yet in 1871, the accomplishments of early Chicago went up in flames. What residents and visitors see on the streets today is a city that reinvented itself, that began with ruins and rebuilt a mecca of culture and commerce on the banks of the Chicago River.

By 1875, most evidence of the blaze had disappeared. Steel skyscrapers made their debut in 1885, the Columbian Exposition, or World's Fair, welcomed visitors in 1893, Frank Lloyd Wright began his innovative architectural work in 1889, and before long Chicago was drawing international attention.

Today, the city boasts over 7,000 restaurants, 200 live theaters, 49 museums, and 25 postsecondary institutions. There are 15 miles of beaches, 18 miles of lakeside cycling paths, and over 200 annual parades. Add all that to a tradition of hospitality and plentiful summer sunshine, and it's no wonder Chicago draws 30 million visitors each year.

Chicago is home to almost 3 million people, living in more than 75 neighborhoods. It's the third-largest city in the nation after New York and Los Angeles and one of the top overnight destinations for visitors.

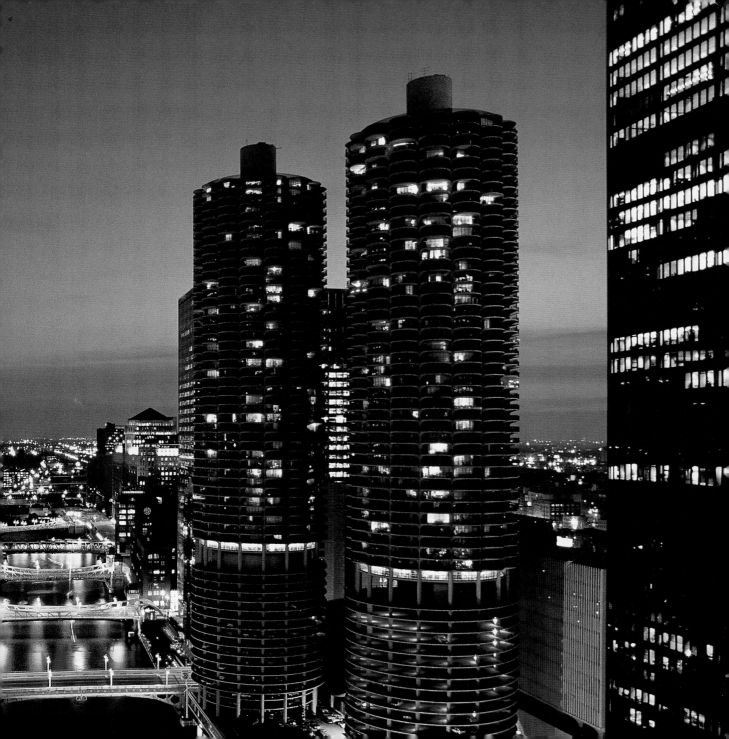

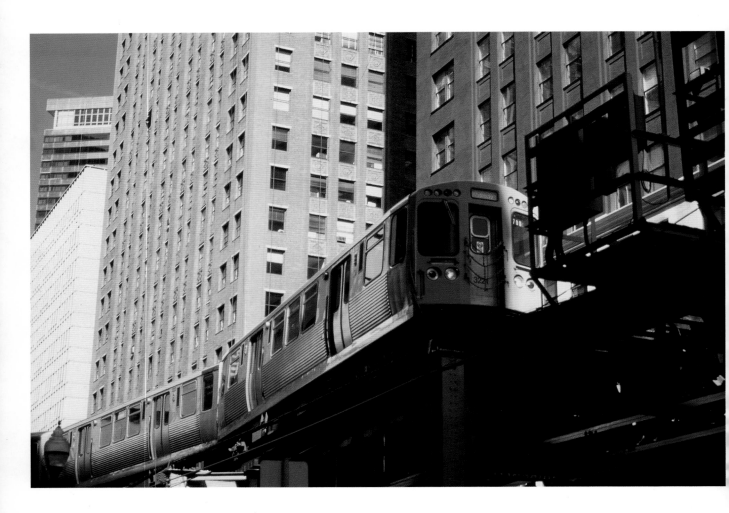

Chicago's elevated train system, called the El, forms a loop encir-
cling Lake Street, Wabash Avenue, Van Buren Street, and Wells
Street. Because of this route, downtown Chicago is known as
The Loop.

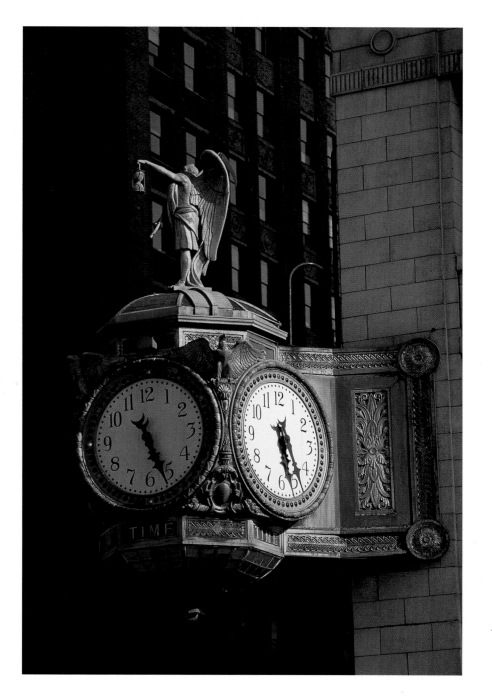

The Father Time Clock hangs above the traffic at 35 East Wacker Drive. The clock's face is encircled by small red lights that shine at night like jewels. Fittingly, the building on which the clock hangs was formerly known as the Jewelers' Building.

Sprawling over 4.2 million square feet (over 96 acres), the Merchandise Mart is the largest trade center in the world. Founded by Marshall Field & Company in 1930, and owned by the Kennedy family since 1945, this enormous wholesale store hosts over 300 conventions, seminars, and special events each year.

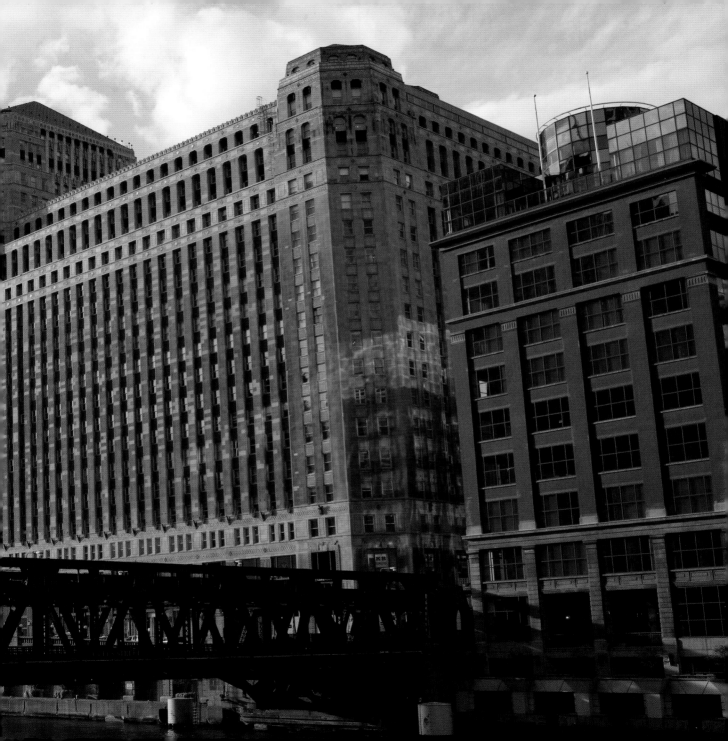

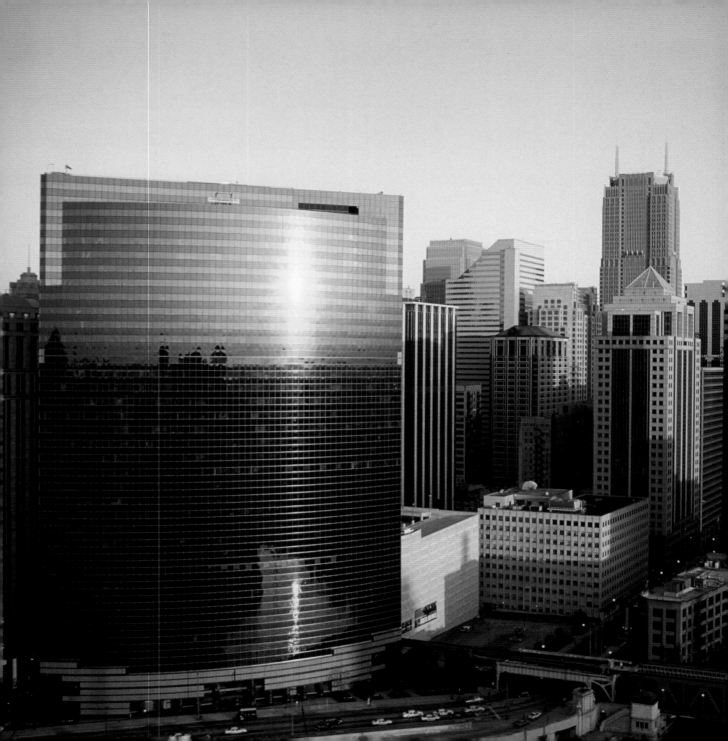

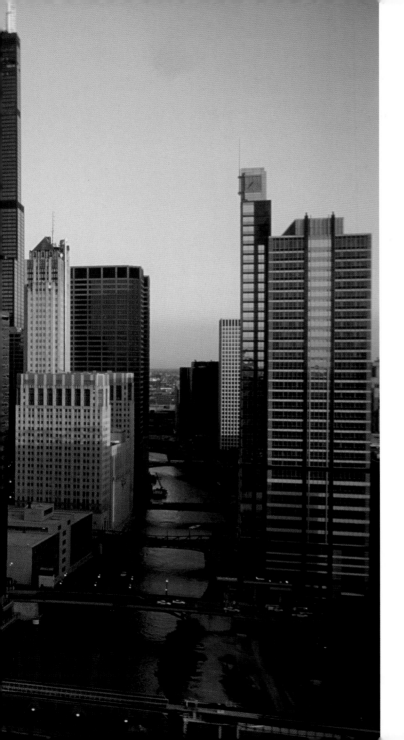

Marking the northwest corner of Chicago's Loop district, the curved wall of green glass that forms the exterior of 333 W. Wacker Drive follows a bend in the Chicago River. The innovative building was designed by architects Kohn Pederson Fox to reflect the stone buildings around it.

The postmodern design of architect Helmut Jahn and the vivid blue, pink, and silver exterior make the James R. Thompson State of Illinois Center one of the most easily recognized downtown buildings. The complex is named for a former Illinois governor and houses many government offices.

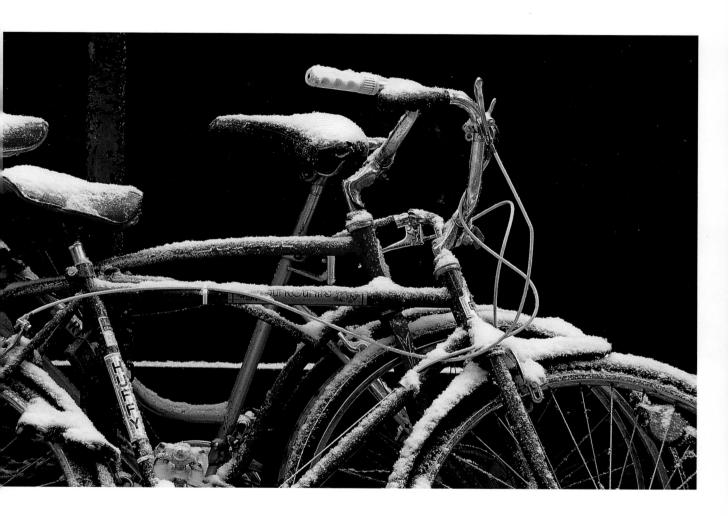

Bicycling magazine has ranked Chicago in the top 10 American cities for cycling. But when the average temperature in the Windy City drops to 21°F in January, most people leave their bikes at home.

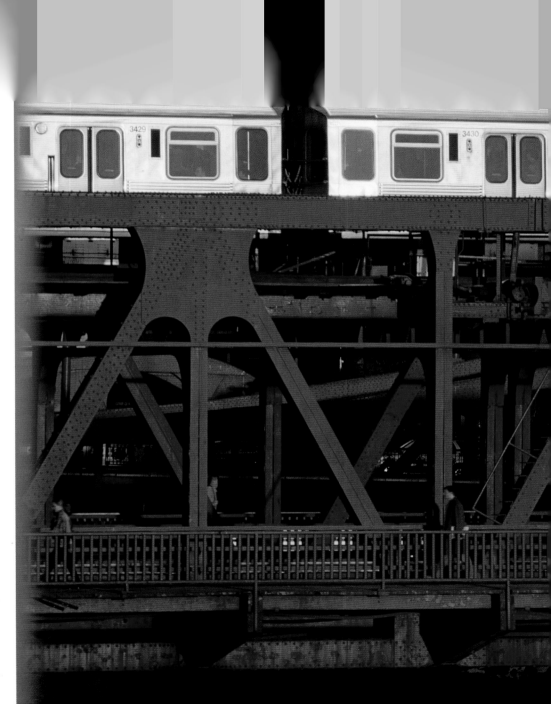

Chicago's first rapid transit system opened in 1892. Portions of the original track are still in use as part of the Blue and Pink Lines. The Brown Line, pictured, opened in 1907 and remains virtually unchanged, aside from minor cosmetic upgrades to stations and elevated structures.

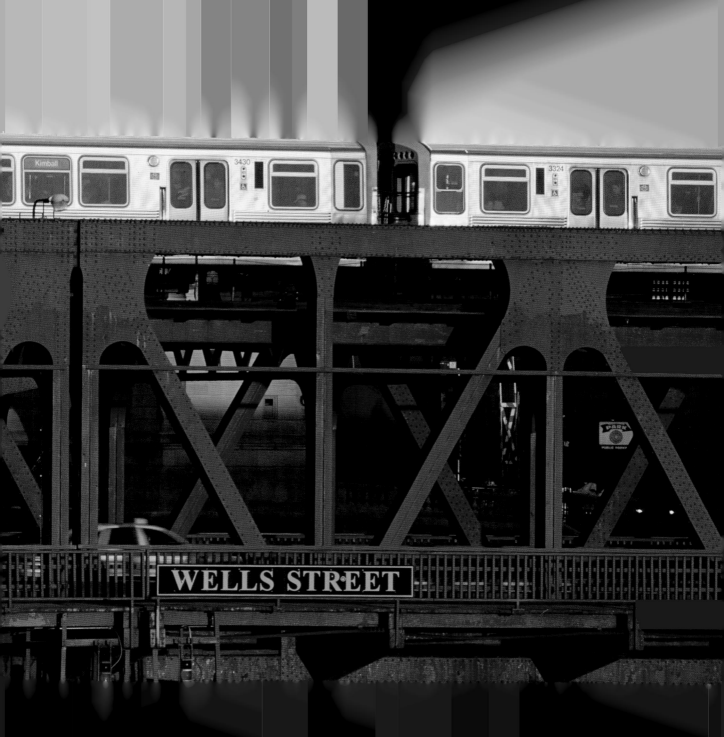

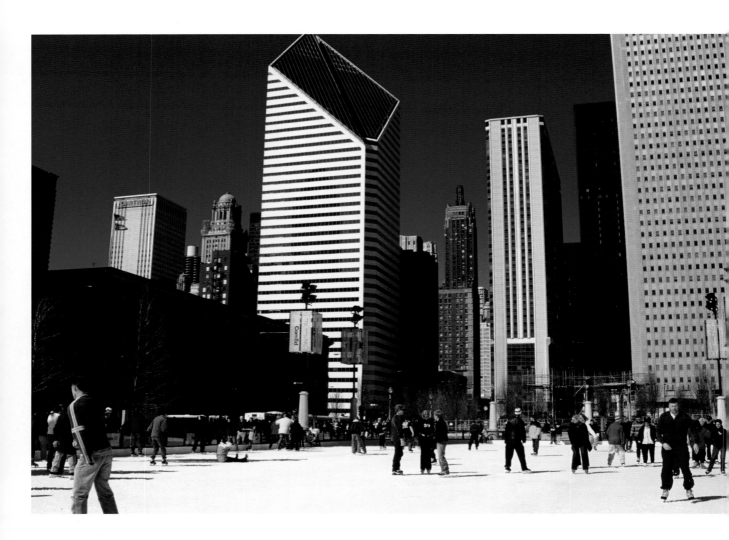

Chicago receives about 40 inches of snow each winter, and
the temperature hovers below 32°F for more than 120 days
in the average year.

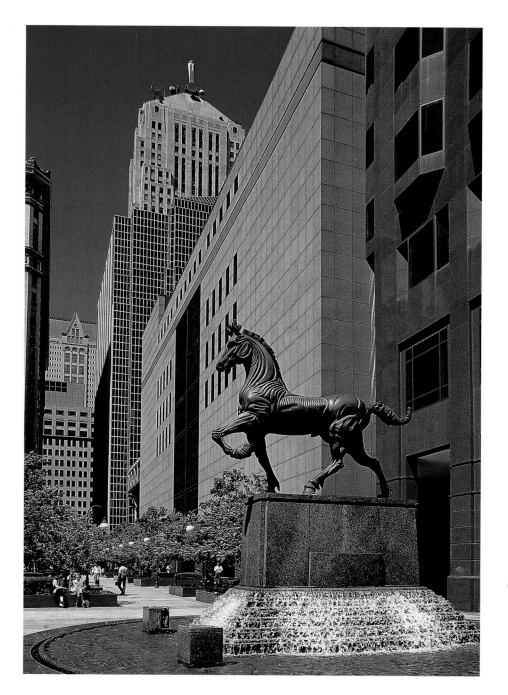

This fountain is one of the hundreds of sculptures found in city plazas and parks. In 1978, Chicago became one of the largest cities in the United States to require that funding for public art be included in municipal renovation and construction plans.

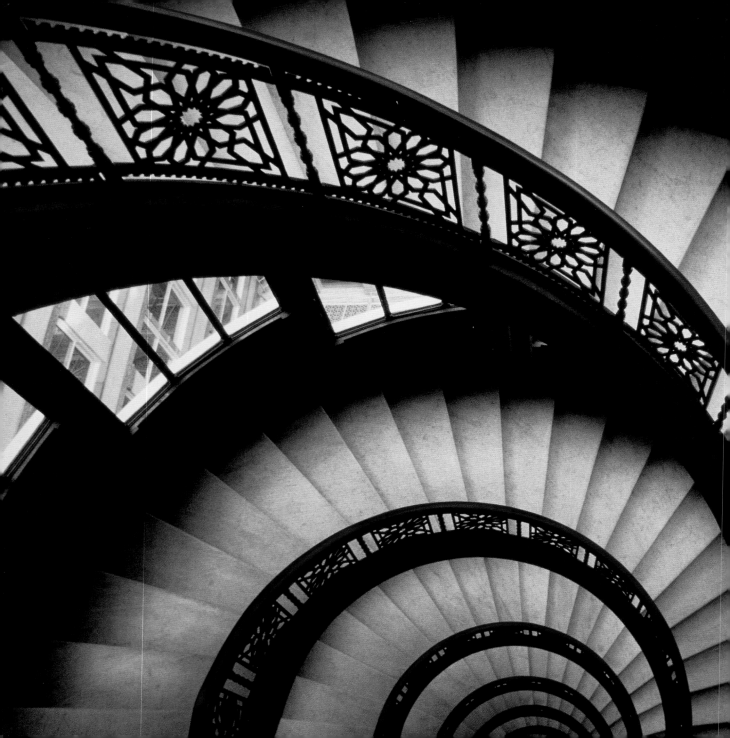

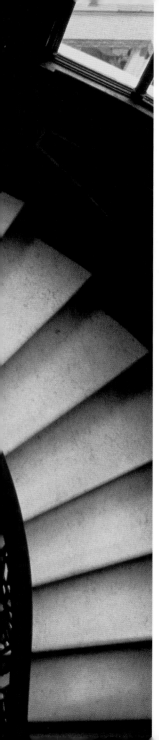

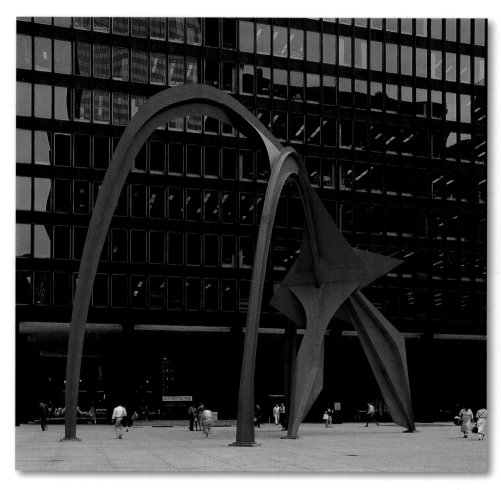

American sculptor Alexander Calder envisioned a work that would draw people into Federal Plaza and break the straight lines of the surrounding buildings. He created the distinctive 53-foot-tall *Flamingo* in 1974.

This celebrated marble semispiral staircase rises from the lobby of The Rookery, a skyscraper in Chicago's Loop district. Remodeled in 1905 by architect Frank Lloyd Wright, the lobby features ironwork of his own design.

The large expanse of windows on the front of The Blue Cross–Blue Shield Tower is often used as an illuminated billboard, with words spelled out by opening and closing window shades. The building's location, facing Grant Park, makes it an ideal canvas for celebrating happenings around the city.

Chicago was first dubbed the Windy City in 1893 by Charles Dana, a *New York Sun* editor. Tired of hearing about the wonders of the Columbian Exposition, he hoped to stop the boasting of city residents.

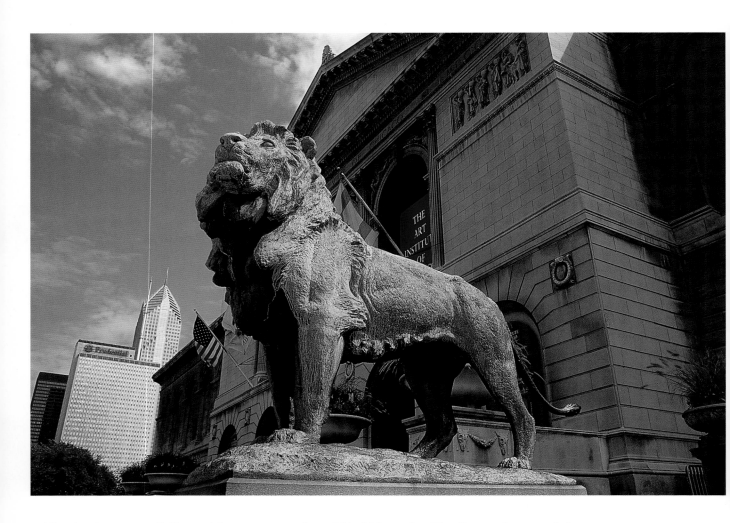

The Art Institute of Chicago houses more than 300,000 works. The lions who guard the entrance were designed in 1894 by Edward L. Kenrys, a self-taught sculptor who originally trained as a dentist. He studied lions in the wild before embarking on this work.

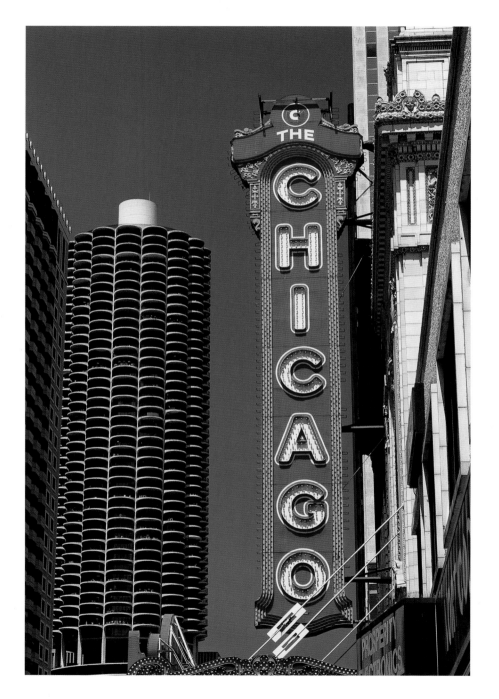

When it opened in 1921, the Chicago Theater was billed as the "Wonder Theater of the World." Its ornate interior drew thousands of movie-goers more than happy to pay extra for the plush environ-ment, which included one of the city's first air conditioners. The rounded walls of the Marine Tower were said to house a "city within a city." One of the first urban com-plexes built after the Second World War, the building is often credited with begin-ning a residential revitalization in American inner cities.

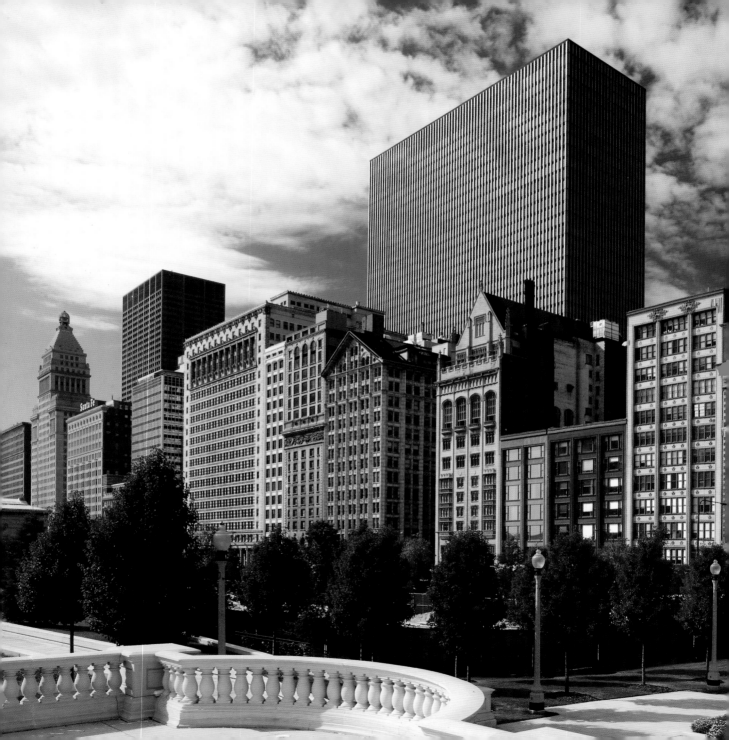

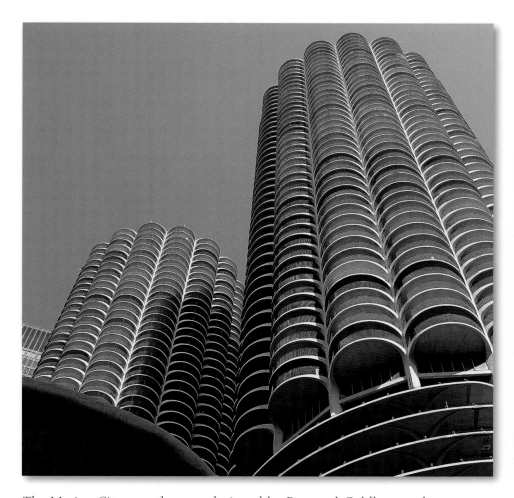

The Marina City complex was designed by Bertrand Goldberg and completed in 1964. Nicknamed "the corncobs" by local pundits, the round towers are supported in the center by huge cylinders.

A blend of historic and modern architecture gives Chicago its unique character.

When it was dedicated in 1927, Buckingham Fountain was the largest decorative fountain in the world—its water shooting 135 feet high. It was commissioned by arts patron Kate Sturges Buckingham and inspired by the Latona Basin Fountain in Versailles.

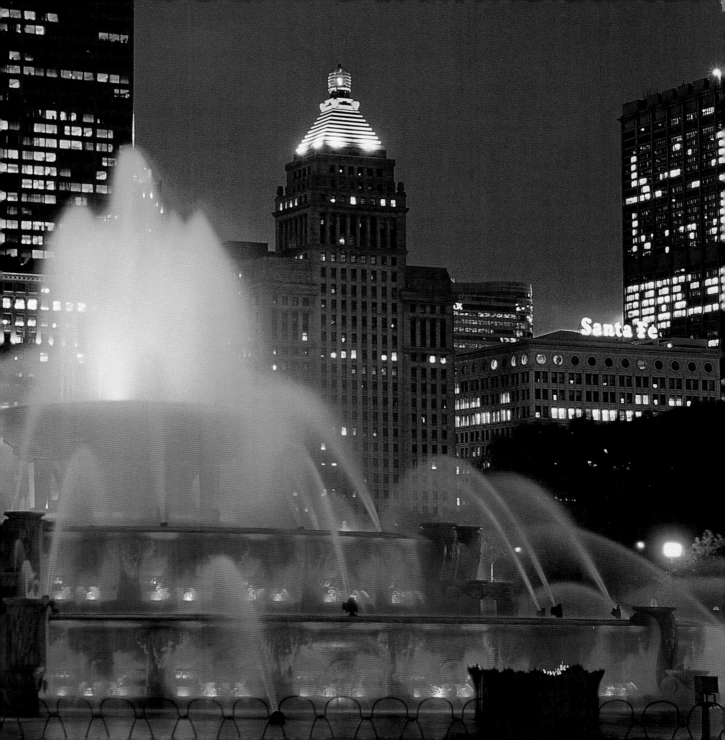

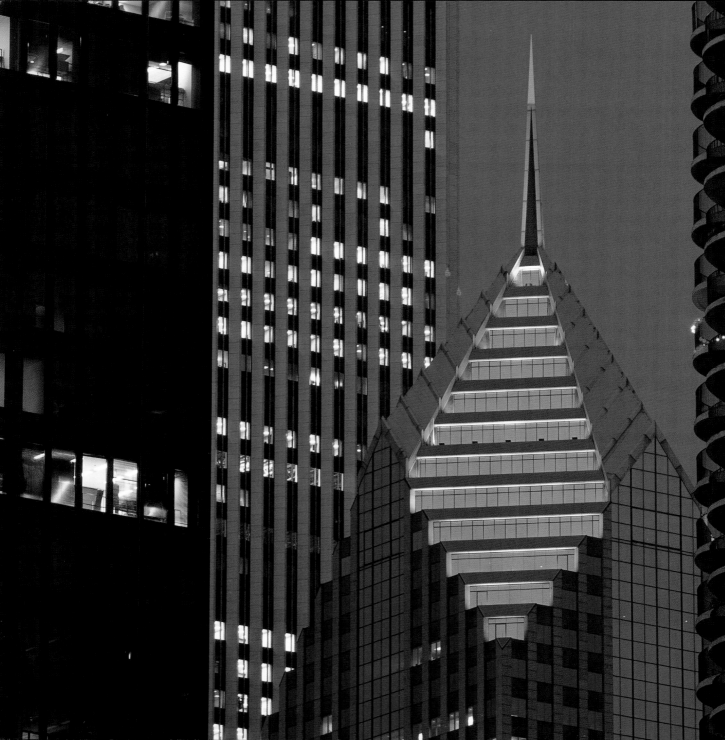

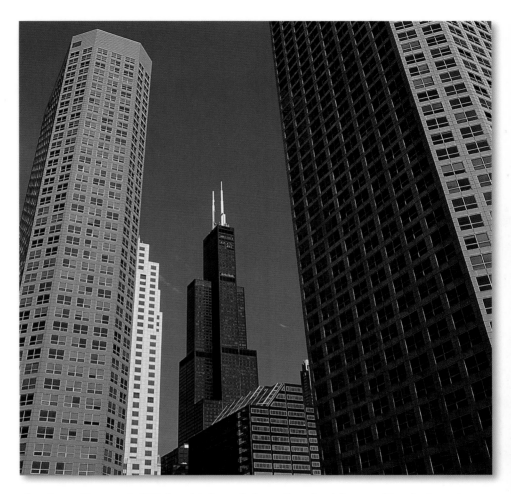

The Sears Tower, 1,455 feet high and the tallest building in North America, has soared above the city skyline since 1974. About 1.4 million visitors a year ride the elevators to the Skydeck at the top of the tower.

Home to the offices of many high-profile corporations, One Prudential and Two Prudential Plaza are among Chicago's most famous skyscrapers. Built in 1990, Two Prudential Plaza, shown here, soars 65 stories—995 feet—tall.

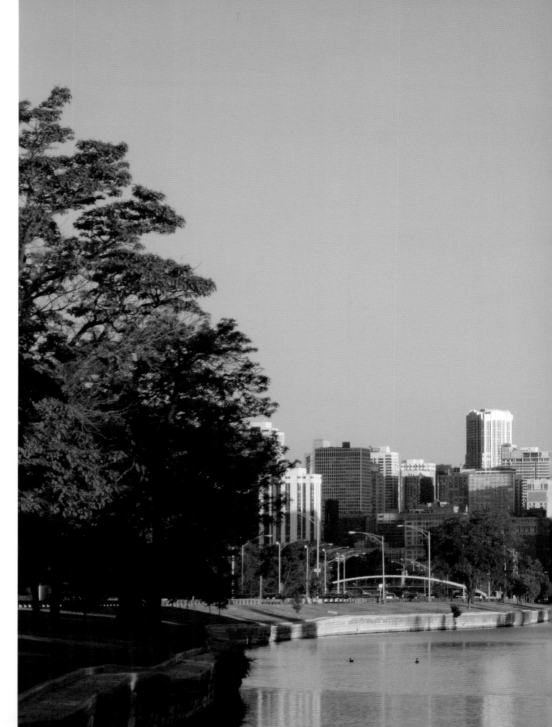

The Sears Tower pokes out of the Chicago skyline as dusk hovers over South Lagoon. Though no longer the home of Sears, Roebuck & Company, the tower's offices are still among the city's most prestigious business locations.

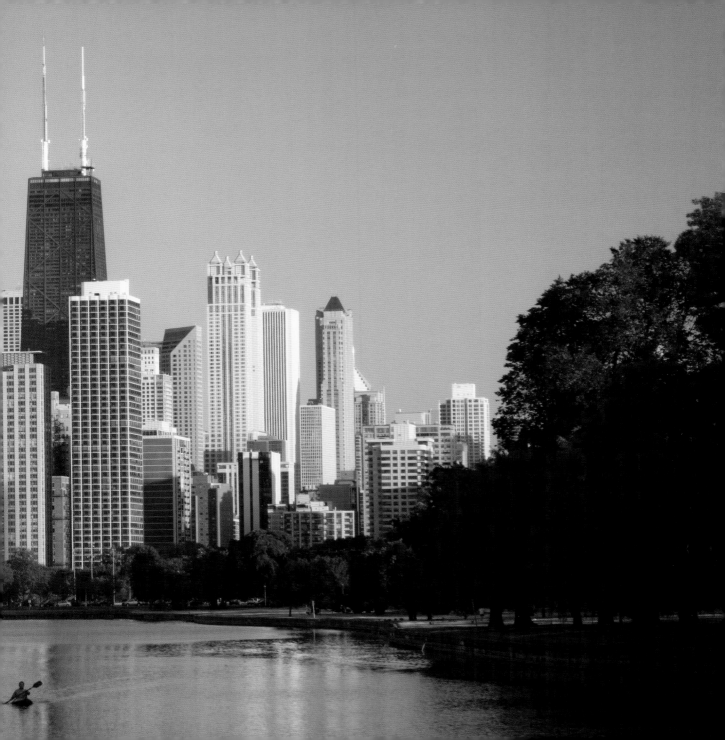

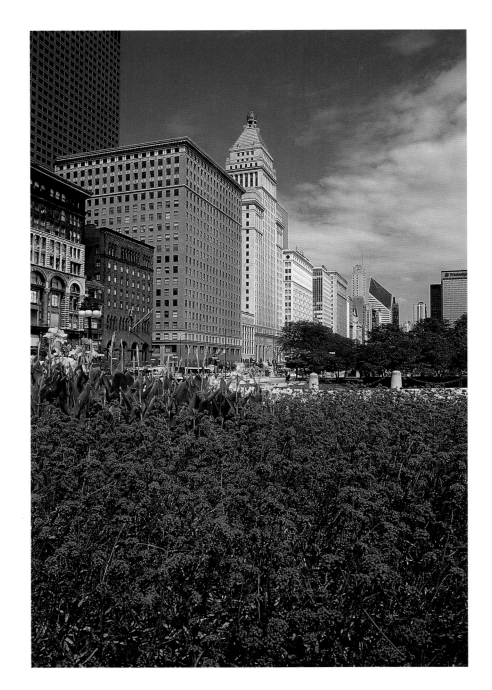

Frequently referred to as Chicago's front yard, Grant Park occupies 319 acres of downtown Chicago. It is home to some of Chicago's most significant cultural landmarks, including the Art Institute of Chicago, the Adler Planetarium, the Field Museum of Natural History and the Shedd Aquarium.

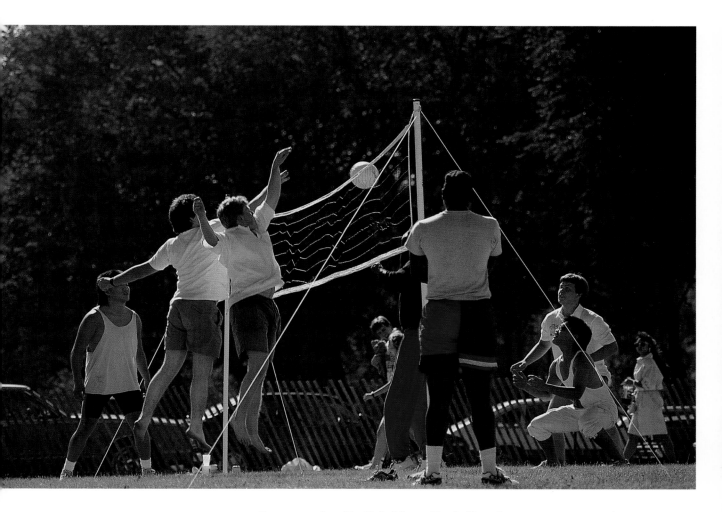

Soccer and softball fields, volleyball and tennis courts, and an outdoor skating rink are some of the sports and recreation facilities available at Grant Park. The annual Chicago Marathon begins and ends in the park.

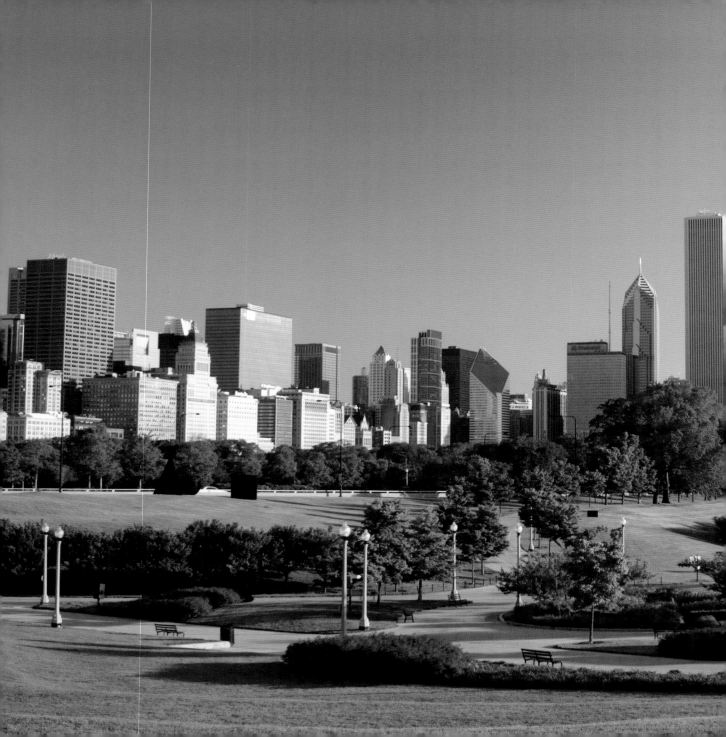

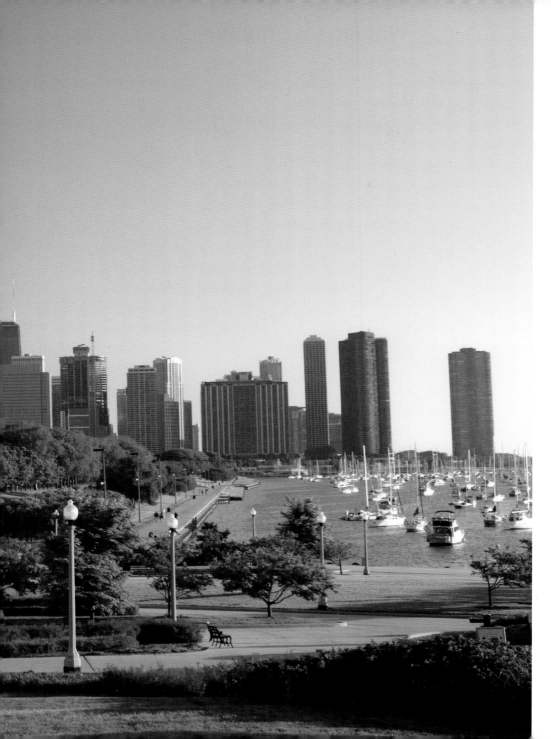

The Lake Shore Trail is a paved, multi-use path that runs along the lakefront the entire length of Grant Park. On a peaceful summer day, it is hard to imagine that this park is the site of some of Chicago's most popular festivals, including the Chicago Jazz Festival, the Chicago Blues Festival and Lollapalooza.

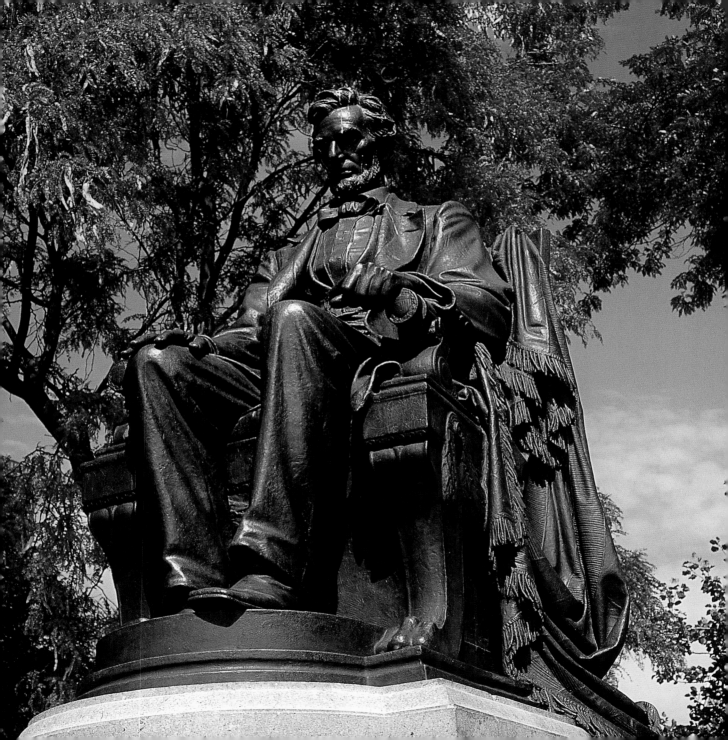

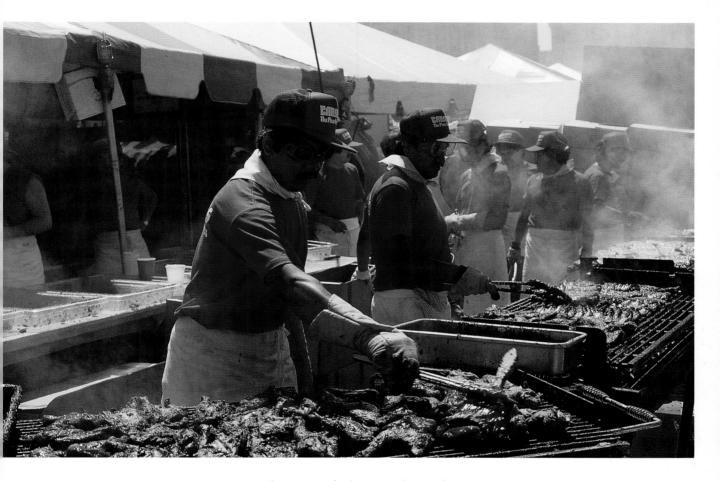

The Taste of Chicago, shown here, the annual Air and Water Show, the Chicago Gospel Festival, Celtic Fest, and countless other citywide celebrations entertain residents and visitors throughout the year.

Chicago honors Abraham Lincoln's many lifetime achievements with five statues located throughout the city. Although born in Kentucky, Lincoln spent the majority of his life in Illinois. Known as the "Seated Lincoln," to differentiate it from the "Standing Lincoln" in Lincoln Park, the Grant Park statue evokes the loneliness that Lincoln felt during the American Civil War. Barack Obama, another president who made his home in Illinois, quoted Lincoln in his famous 2008 election victory speech, which he delivered from Grant Park.

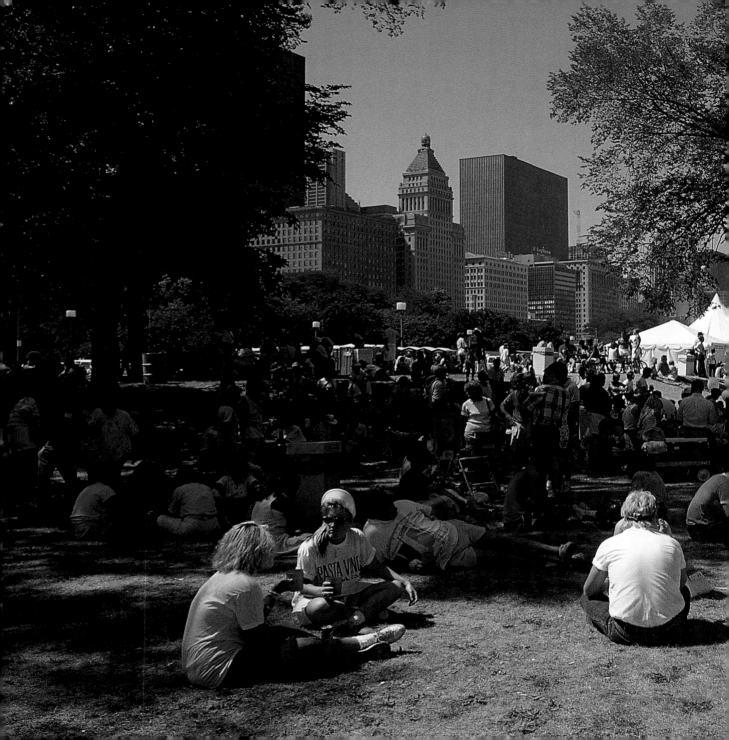

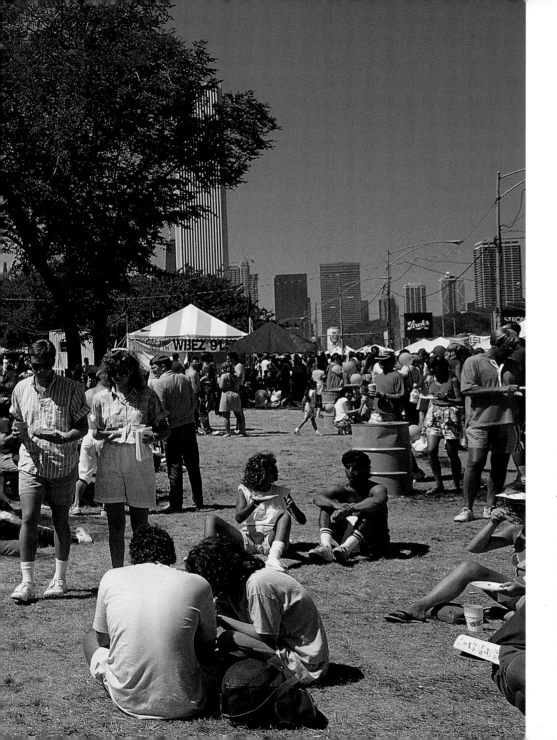

Held for ten days around the Fourth of July holiday, Taste of Chicago is the world's largest food festival. More than 70 vendors from restaurants throughout the city sell Chicago favorites such as deep-dish pizza, Polish sausages, and cheesecake.

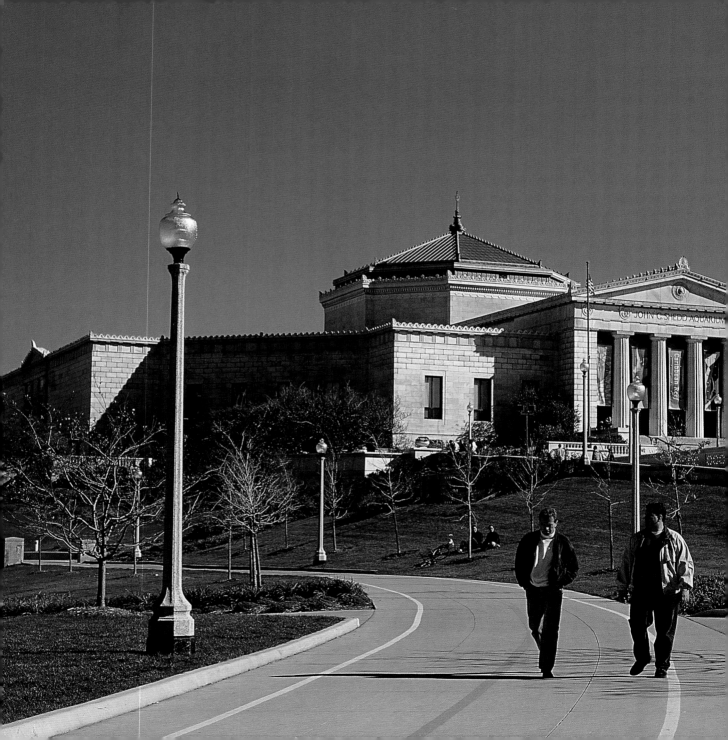

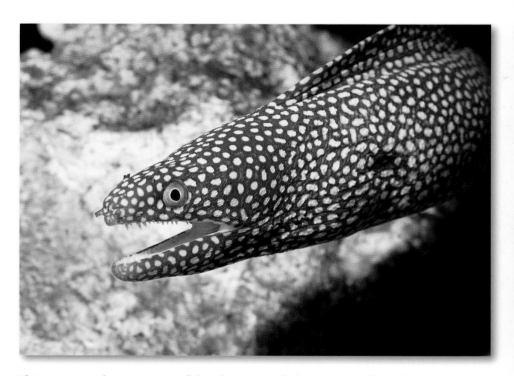

This moray eel is just one of the denizens of the John G. Shedd Aquarium. In the wild, moray eels are nocturnal, hiding in crevices during the day and emerging at night to snare fish, squid, and octopus along coral reefs.

When it first opened on May 30, 1930, the John G. Shedd Aquarium was home to the greatest variety of sea life to be found under one roof. The first inland aquarium with a permanent saltwater collection, the Shedd shipped more than 1 million tons of seawater from Florida by rail.

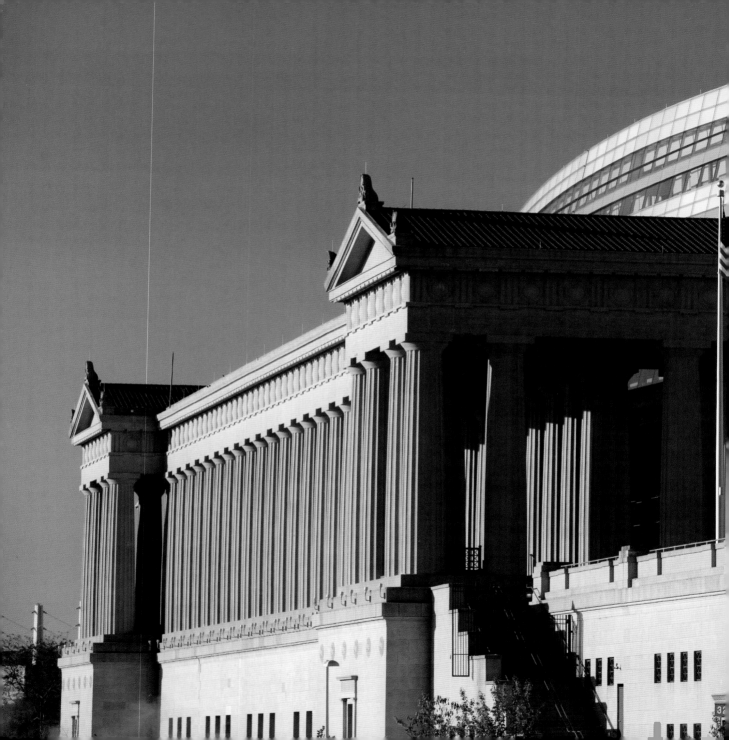

Home to the Chicago Bears, Soldier Field is one of the smallest stadiums in the NFL, with a seating capacity of 61,500. The stadium is often used for concerts; the Grateful Dead played their final show here on July 9, 1995.

Lake Michigan, one of the five Great Lakes, was formed more than 10,000 years ago. Descending to a depth of 923 feet, the lake holds 1,350 trillion gallons of water and stretches for 22,300 square miles.

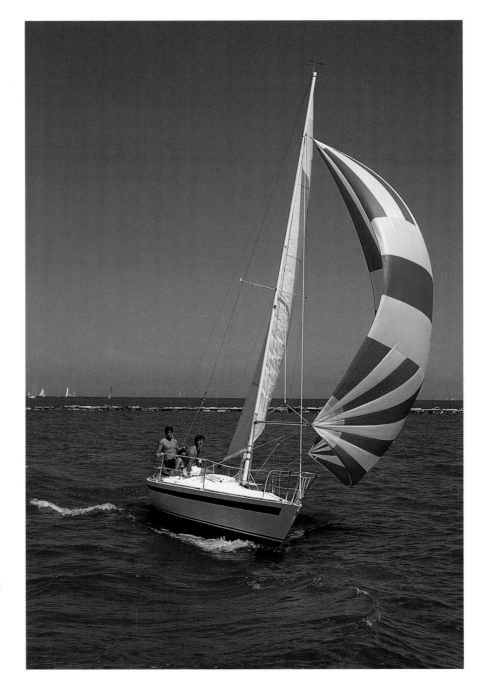

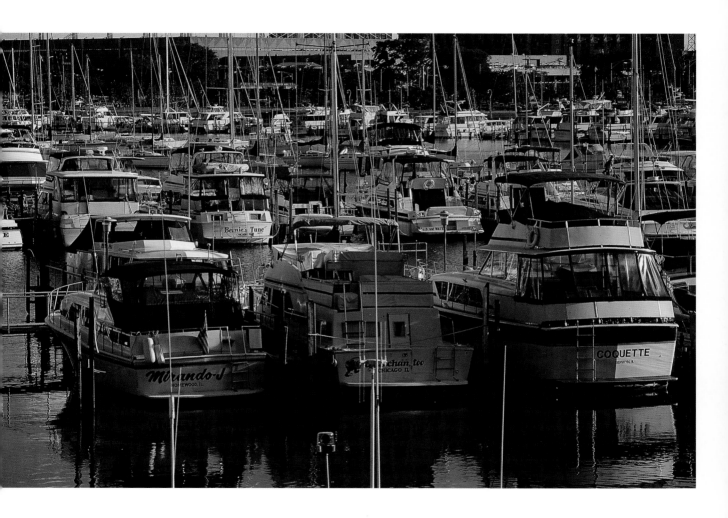

Chicagoans are fond of sailing, and Burnham Harbor is one of the most popular sites for setting out. The harbor is named for Daniel Hudson Burnham, an architect and urban planner whose work transformed Chicago's lakefront.

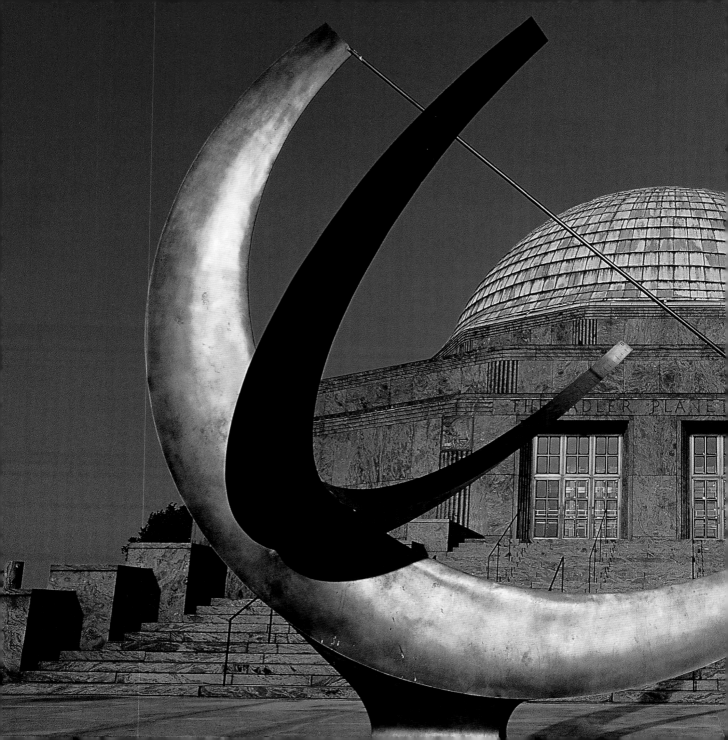

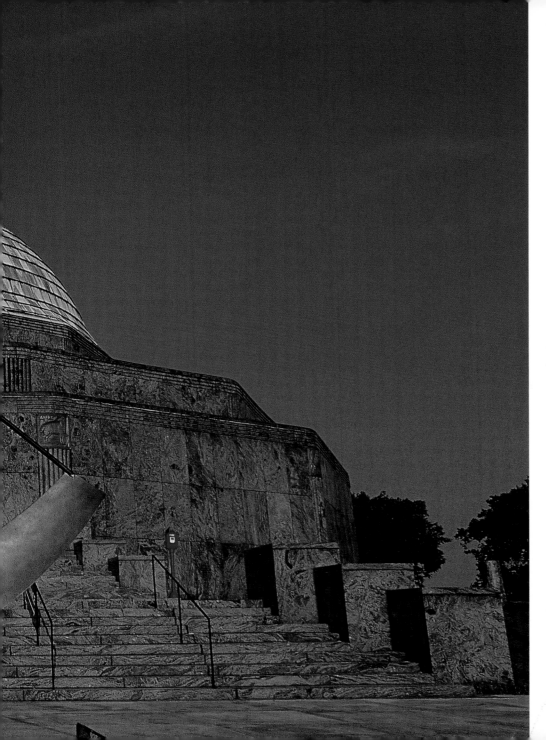

Founded in 1930, the Adler Planetarium and Astronomy Museum was the first planetarium in the Western Hemisphere. The inspiration for the museum came to Max Adler on a trip to Europe, where he witnessed a demonstration of a Zeiss planetarium projector and was fascinated by its ability to accurately depict the night sky. Upon his return to Chicago, Adler donated a projector to the city, along with the funds for a building to house it.

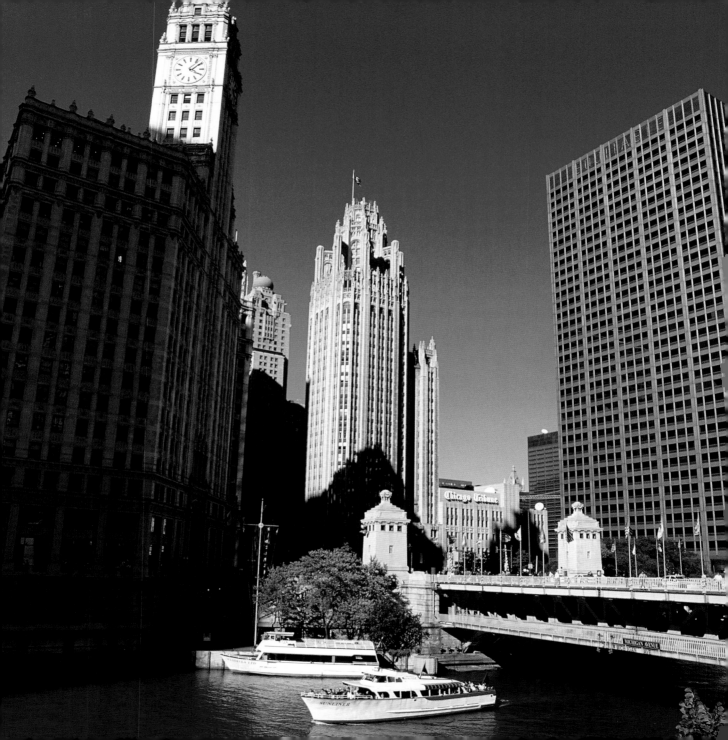

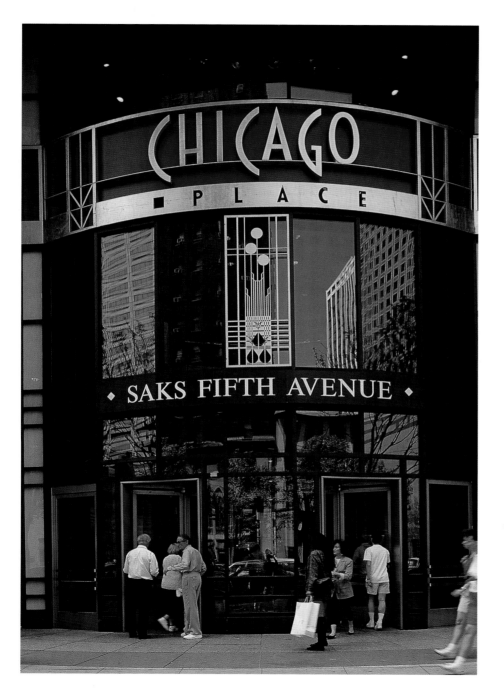

Saks Fifth Avenue is one of six department stores along North Michigan Avenue, known as the Magnificent Mile. One of the world's most famous shopping districts, the avenue has a long history of commerce; this was originally the site of a native trading post.

FACING PAGE—
In the late 1860s and early '70s, tunnels were built under the Chicago River to relieve the traffic jams caused when bridge tenders raised the spans. Some residents successfully took refuge in the tunnels during the Great Fire of 1871.

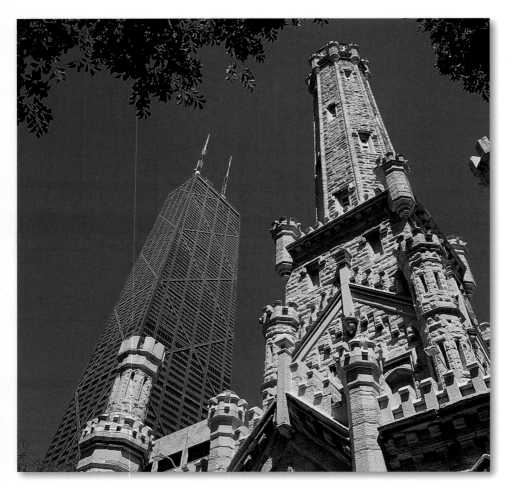

Built to house a nine-foot-wide pipe to stabilize the city's water supply, the Water Tower is now home to a visitor information center and the City Gallery, where visitors can see the works of local photographers.

The Water Tower, with its distinctive limestone facade, was designed by William W. Boyington in 1869 and survived the Great Chicago Fire of 1871. While the technology within is now obsolete, the structure still stands as a memorial to those killed in the blaze.

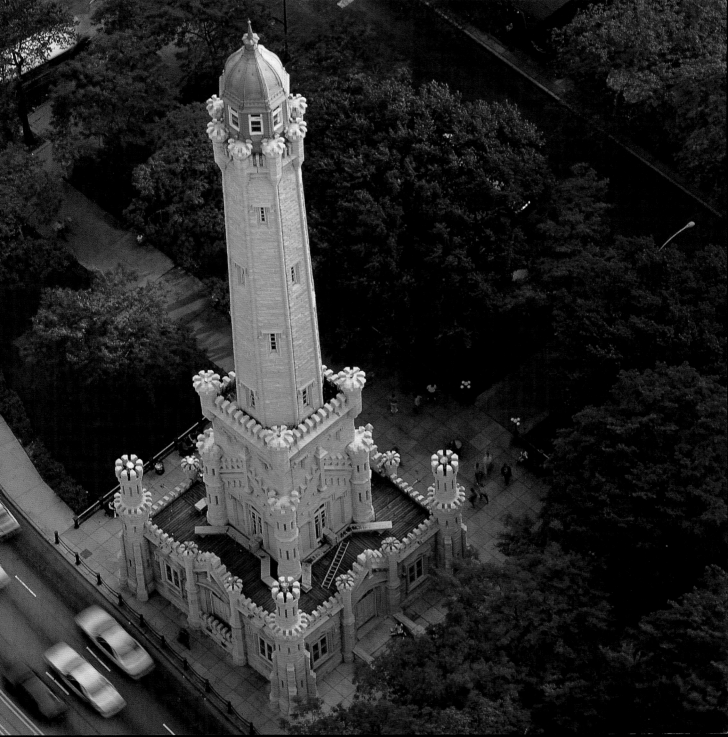

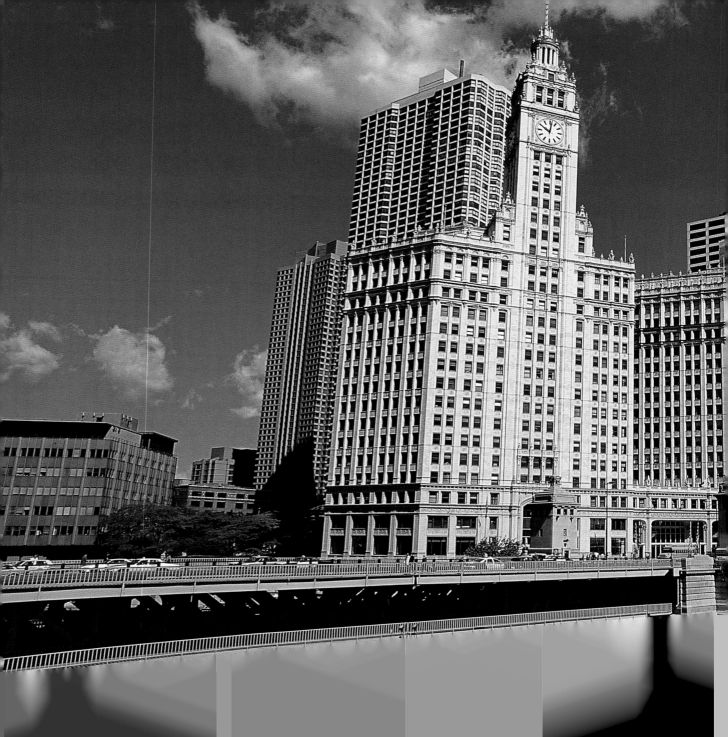

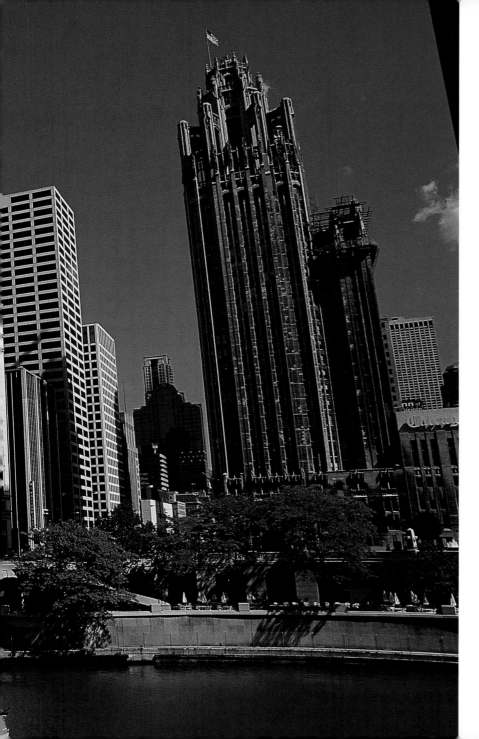

Two of Chicago's most famous skyscrapers stand on the north bank of the Chicago River at the southernmost point of the Magnificent Mile. The Wrigley Building (left) was completed in 1924; it was commissioned by William Wrigley Jr. to serve as the imposing headquarters for his chewing-gum company. In 1922, the *Chicago Tribune* held an international design contest to select the plans for their new office, which they wanted to be "the most beautiful and eye-catching building in the world." John Mead Howells and Raymond Hood's neo-Gothic design was selected from over 260 entries as the winner.

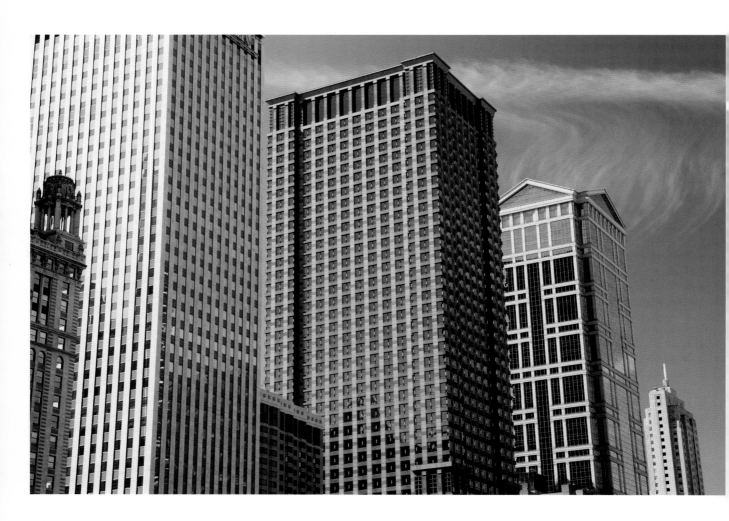

Chicago's downtown, sometimes called The Loop, is densely packed with office towers and is the home to some of the country's first skyscrapers. It's the second-largest area of its kind in the United States after Midtown Manhattan.

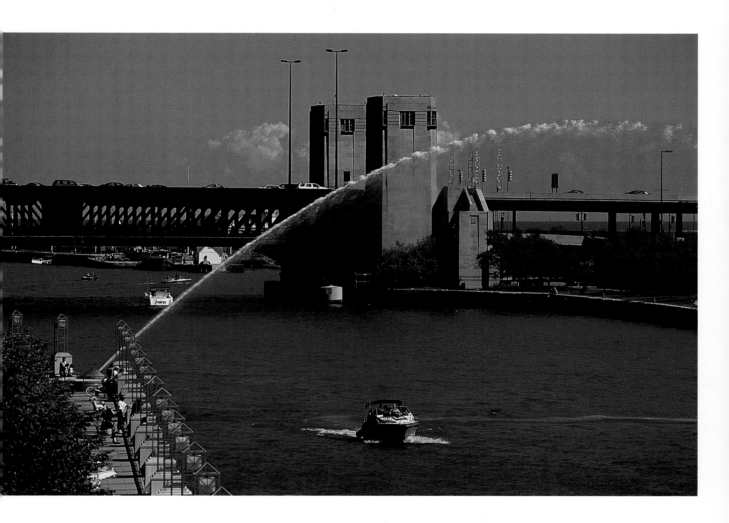

Created in 1989 to celebrate the Water Reclamation District's 100th anniversary, Centennial Fountain marks the place on the Chicago River where the Great Lakes and Mississippi watersheds meet. For 10 minutes every hour, the fountain sends a cascade of water across the river.

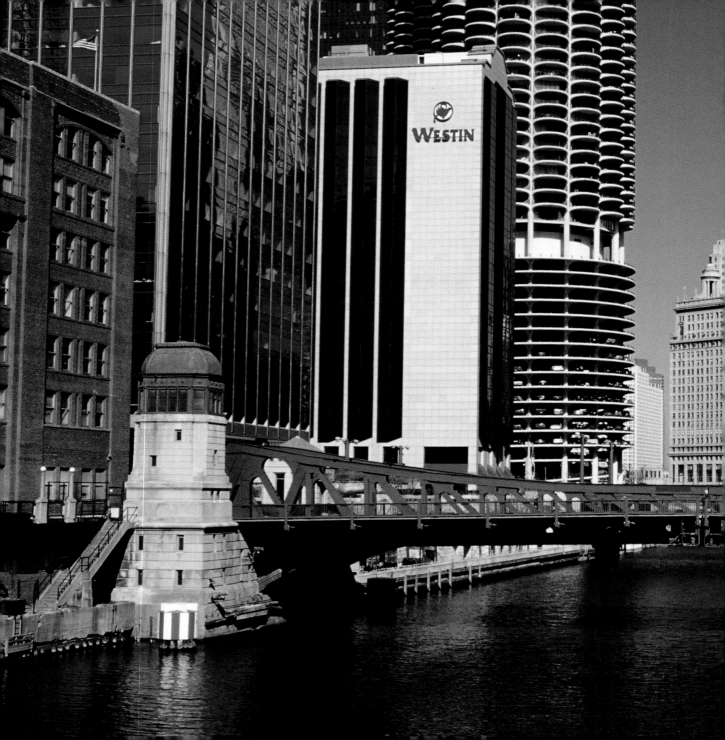

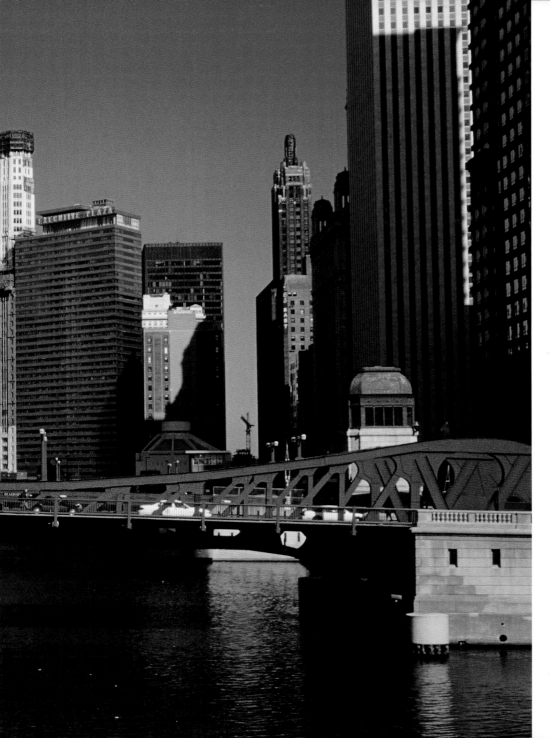

Early Chicago was plagued by cholera and typhoid epidemics, caused by waste pouring into the Chicago River and, from there, into Lake Michigan, contaminating the city's water supply. In what was named the Civil Engineering Moment of the Millennium, engineer Rudolph Hering built a series of canals along the Chicago River, reversing its flow into the Mississippi River system.

Built on the shore
of Lake Michigan,
Northwestern
University held its
first classes, with a
total of ten students,
in 1855. The univer-
sity is known for its
business, law, and
medical schools, and
for its reputation as a
research centre.

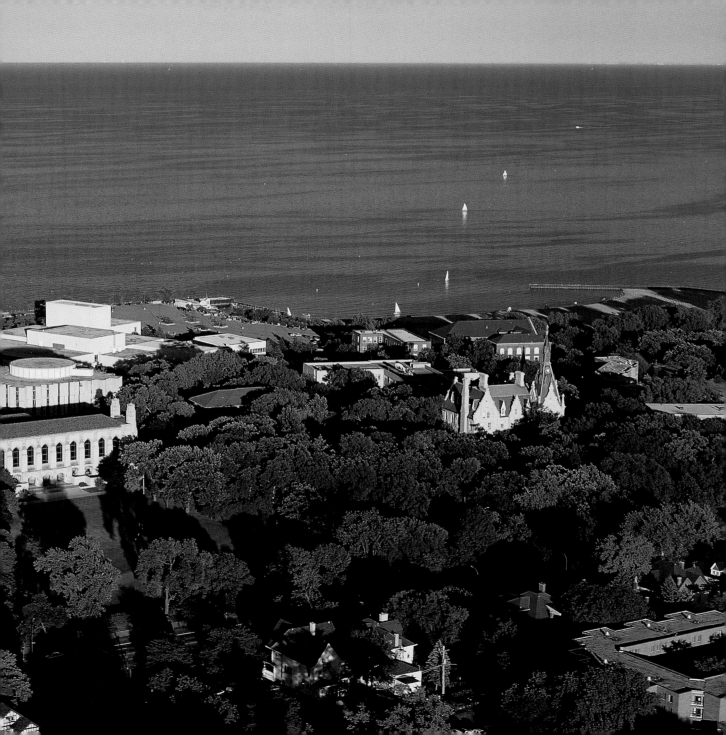

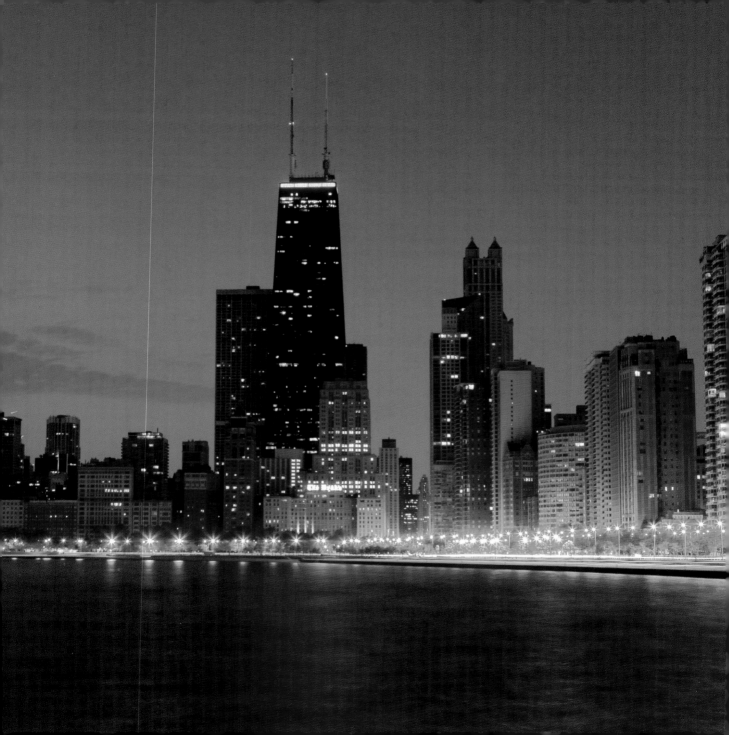

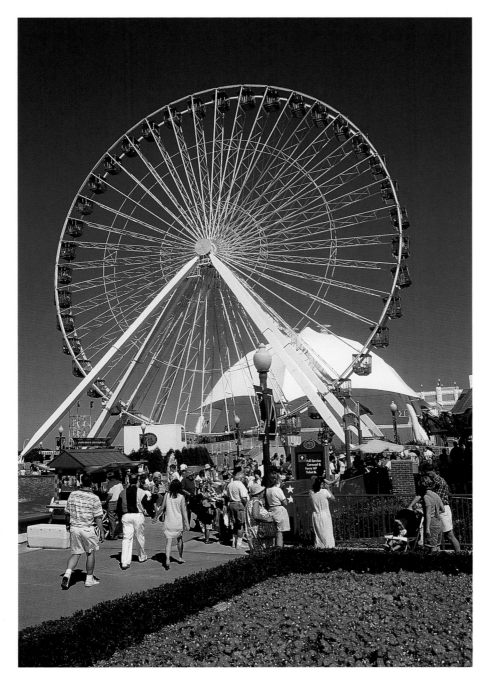

The world's first Ferris wheel was built for Chicago's 1893 Columbian Exposition. Visitors to Navy Pier, an entertainment complex just west of downtown, can soar 150 feet above the river on a reconstruction of the original ride.

FACING PAGE— Chicago's skyline is dominated by the distinctive 100-story Sears Tower. The building's 49 floors of condominiums are the highest residential spaces in the world.

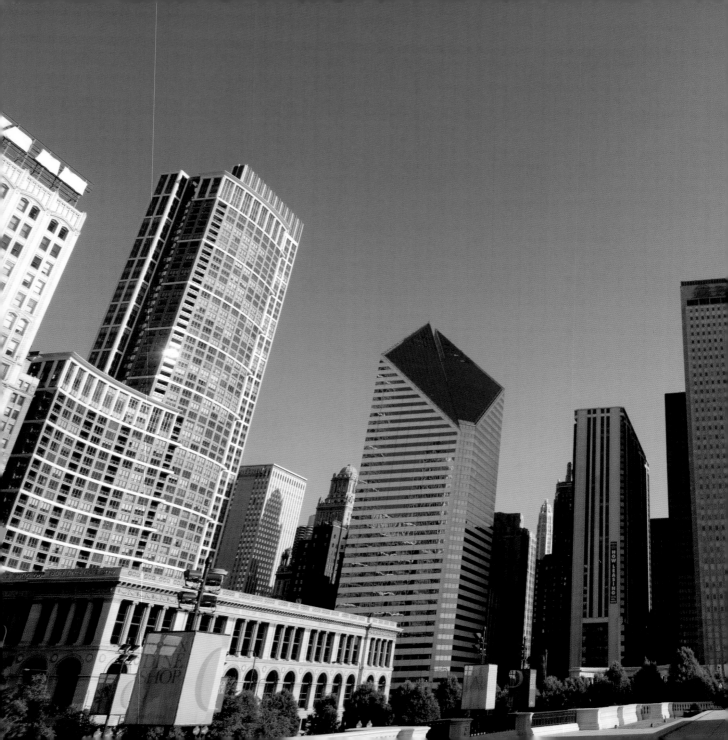

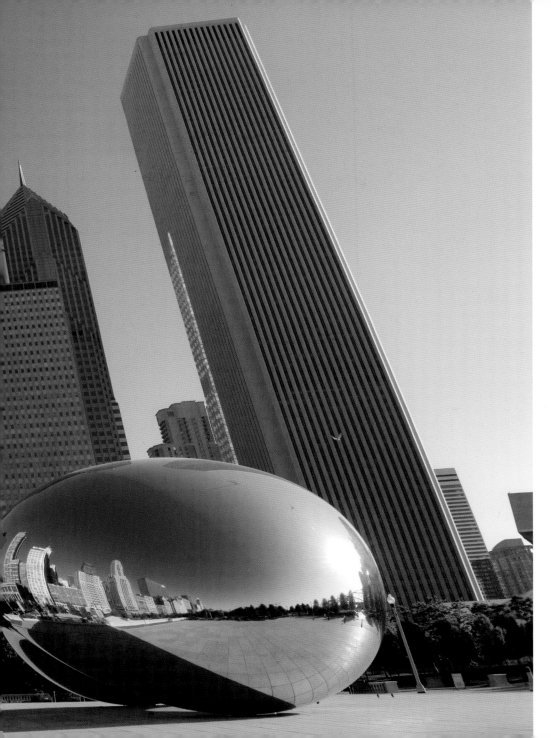

Chicago became an international port in 1959, when the completion of the St. Lawrence Seaway allowed ships to travel from Lake Michigan to the Atlantic. Cloud Gate, a sculpture by Anish Kapoor, is the centerpiece of the AT&T Plaza in Millennium Park. Modeled after liquid mercury, the statue's reflective surface distorts the Chicago skyline.

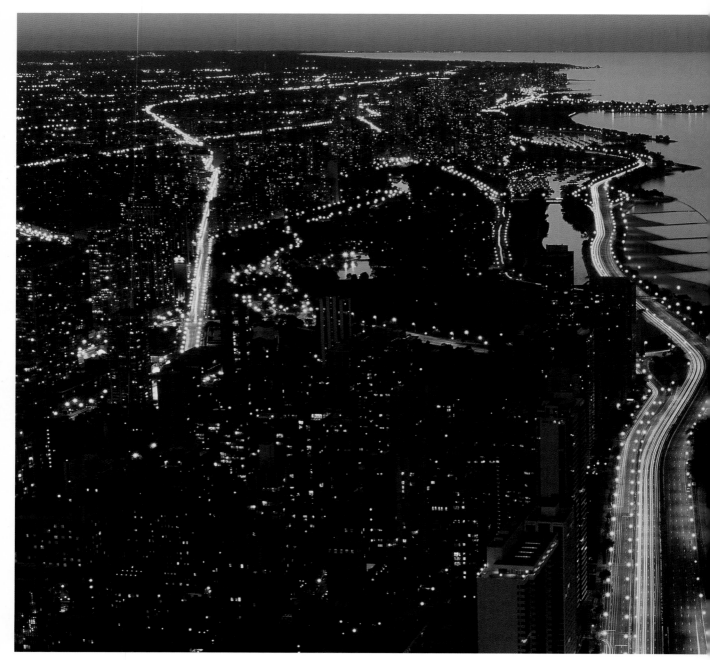

Some of Chicago's most famous former residents include Ernest Hemingway and Louis Armstrong. Both called Chicago home in the early 1920s. More recent famous citizens include Bill Murray, Robin Williams, and Oprah Winfrey, who films her popular television show in the city.

One of the major leagues' oldest ballparks, Wrigley Field was built for $250,000 in 1914. The Chicago Cubs won 7–6 against the Cincinnati Reds in the first game held there, in 1916.

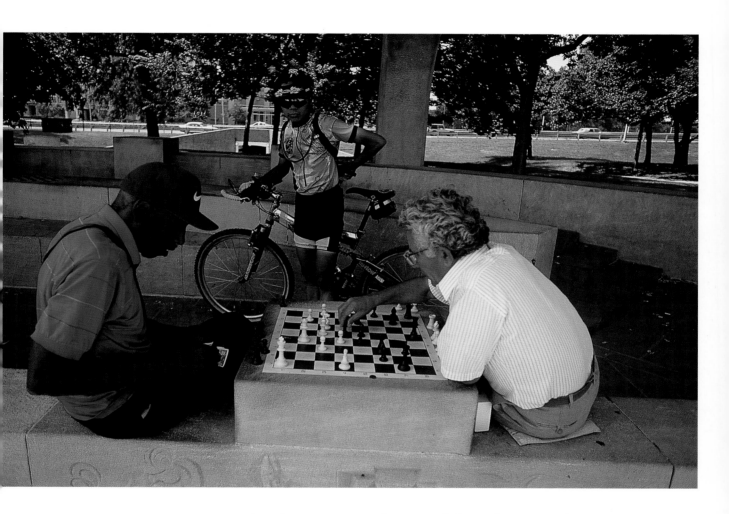

A cyclist stops to watch two avid chess players match wits in Lincoln Park. Chicago's largest preserve, the park includes running, walking, and bridle paths, woodlands, golf courses, two lagoons, and more.

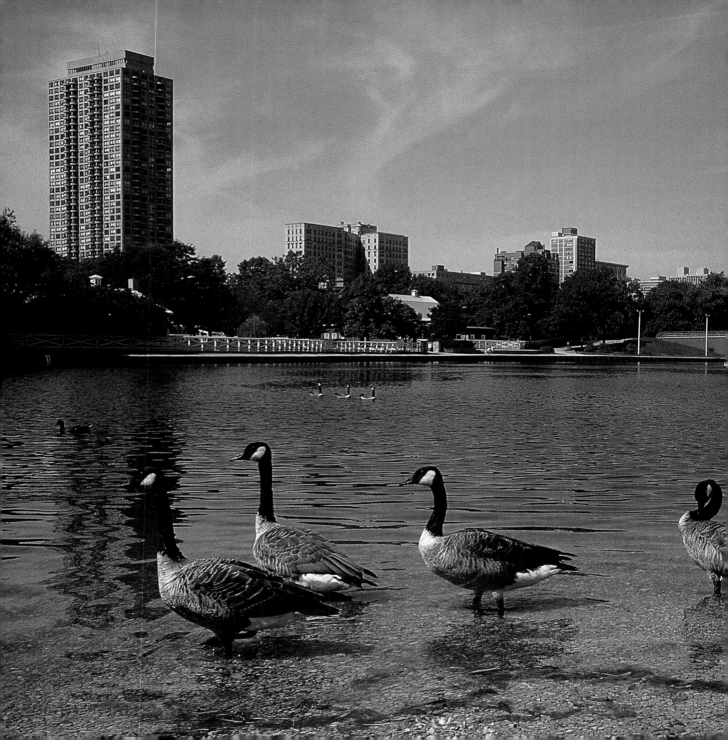

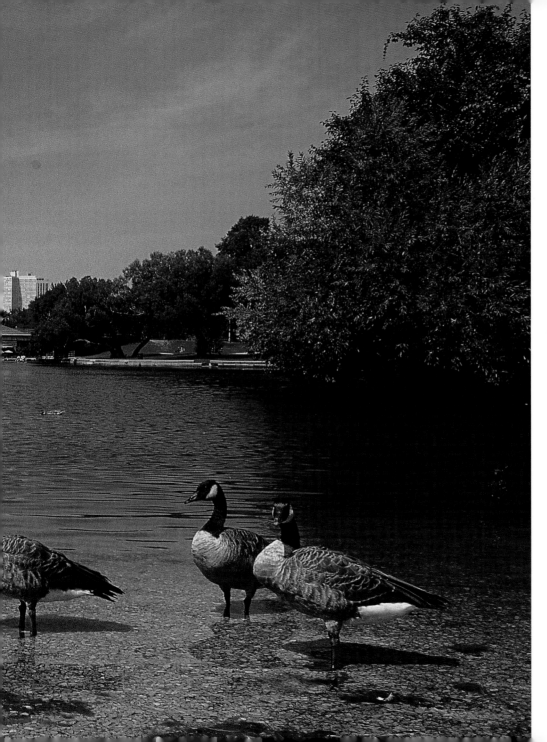

Lincoln Park was named for former President Abraham Lincoln, the first of the nation's leaders to hail from Illinois and the first who was not from one of the original 13 colonies of the United States.

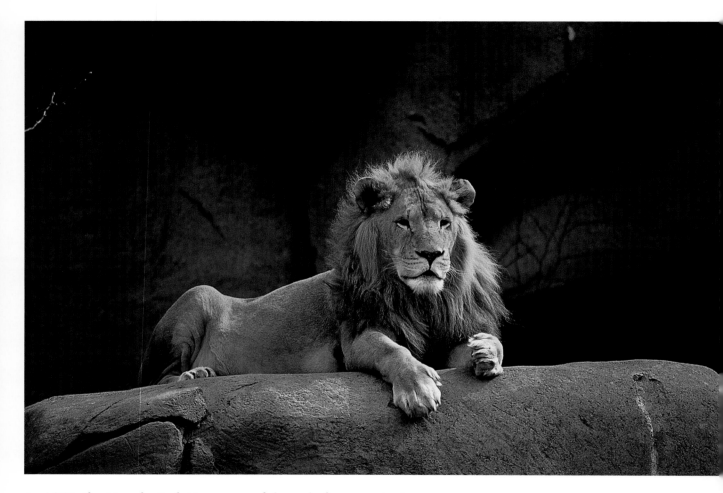

In 1868, the Lincoln Park Zoo—one of the only free zoos in the country—opened with just two attractions: a pair of swans. It now houses more than 1,000 creatures, from boa constrictors and spiders to camels and gorillas. The Kovler Lion House is home to African lions, snow leopards, jaguars, and other wildcats.

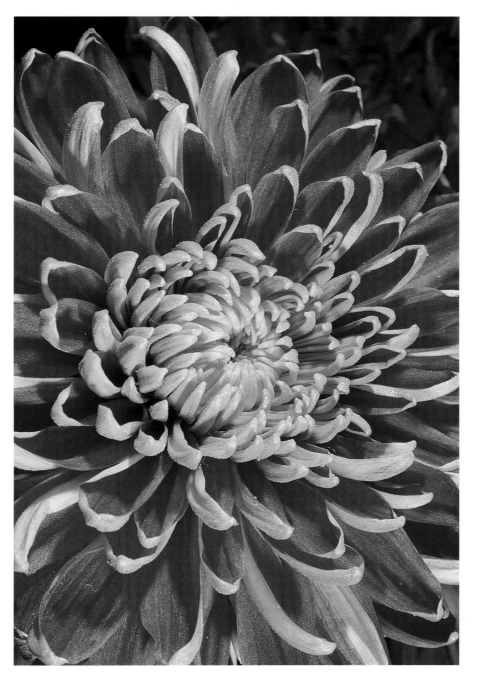

The chrysanthemum is the city's official flower. Prize-winning specimens such as this vivid bloom, and hundreds of others, are part of the Chrysanthemum Show held annually at Lincoln Park.

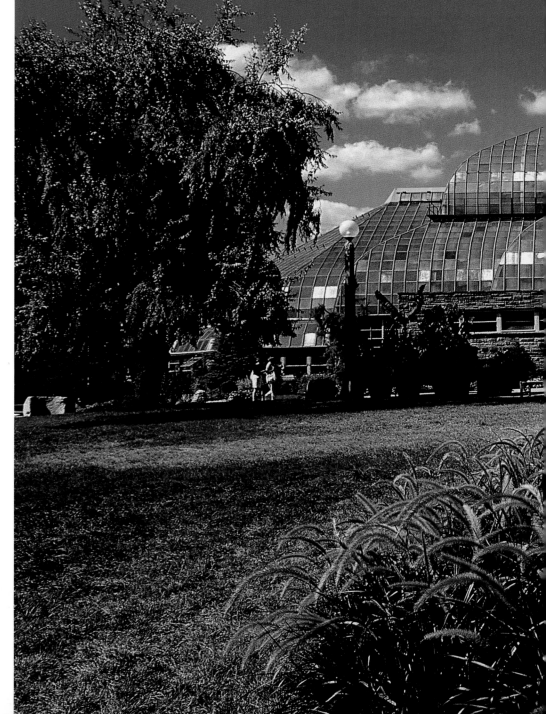

Inspired by London's
Crystal Palace,
Lincoln Park's
Conservatory features
four greenhouses sur-
rounded by a French
formal garden and
an English perennial
garden. Out front sits
a bust of Sir Georg
Solti, the celebrated
conductor of the
Chicago Symphony
Orchestra. Before
his death in 1997,
Solti conducted 999
performances with
the CSO and won 31
Grammy Awards, the
most ever awarded to
one person.

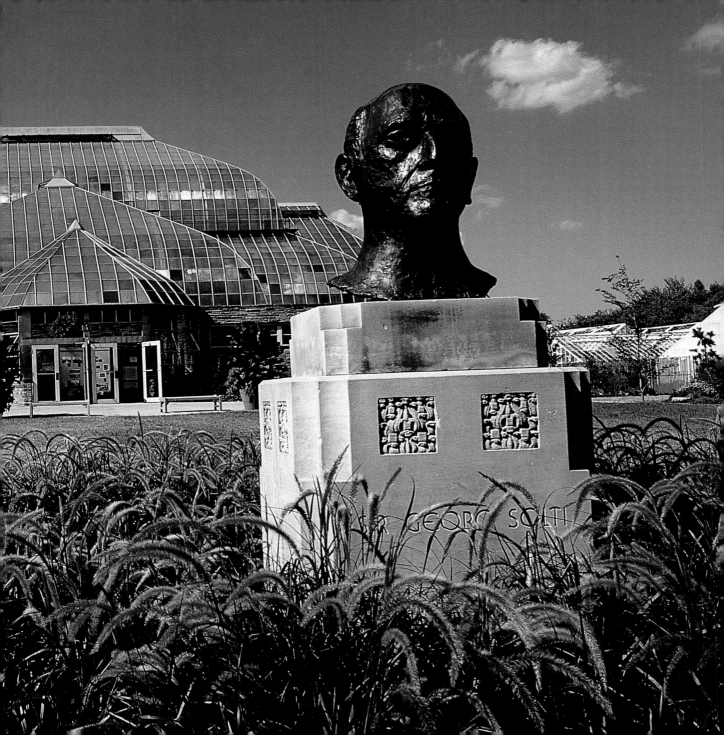

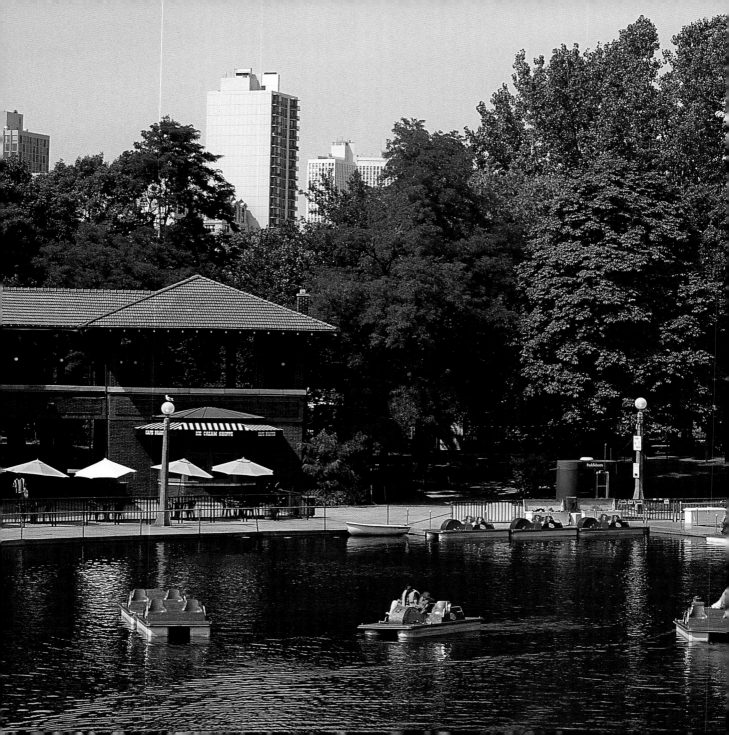

Lincoln Park was once a graveyard— 10,000 soldiers who fought in the Civil War were buried here. In 1864, the bodies were relocated, and the 1,000-acre park was established.

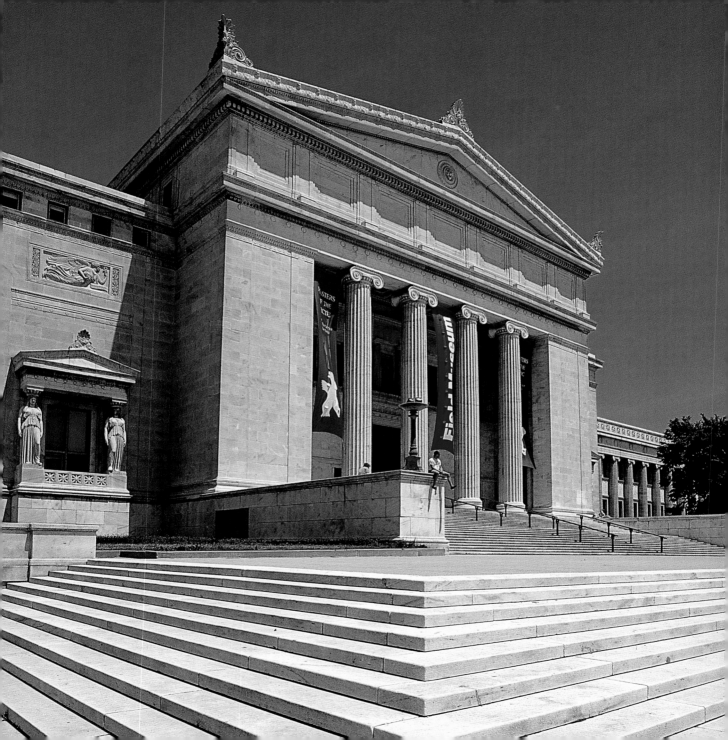

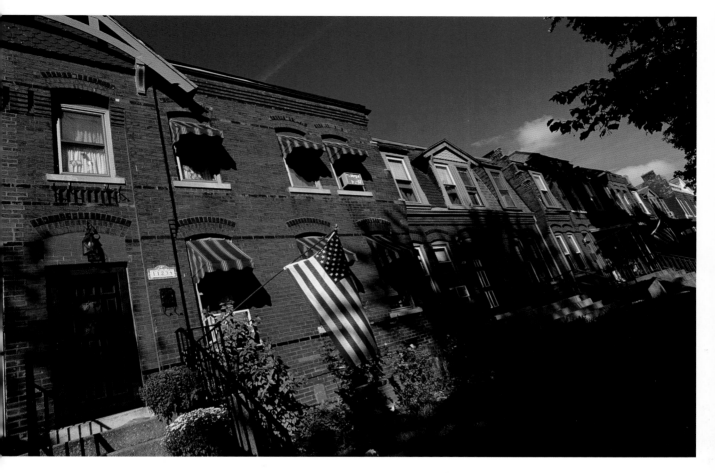

Historians disagree about the origins of Chicago's name. Some believe that it comes from the native word *checagou*, meaning "great" or "powerful."

Endangered animals and amazing birds, ancient Egypt and native culture—visitors to the Field Museum of Natural History explore the worlds of art, archaeology, science, and history. The museum is named for Chicago businessman and philanthropist Marshall Field.

Originally the Palace of Fine Arts, the Museum of Science and Industry in Hyde Park was built in 1893 for the Columbian Exposition. Thirteen-foot-tall, Greek-style maidens surround the entrance.

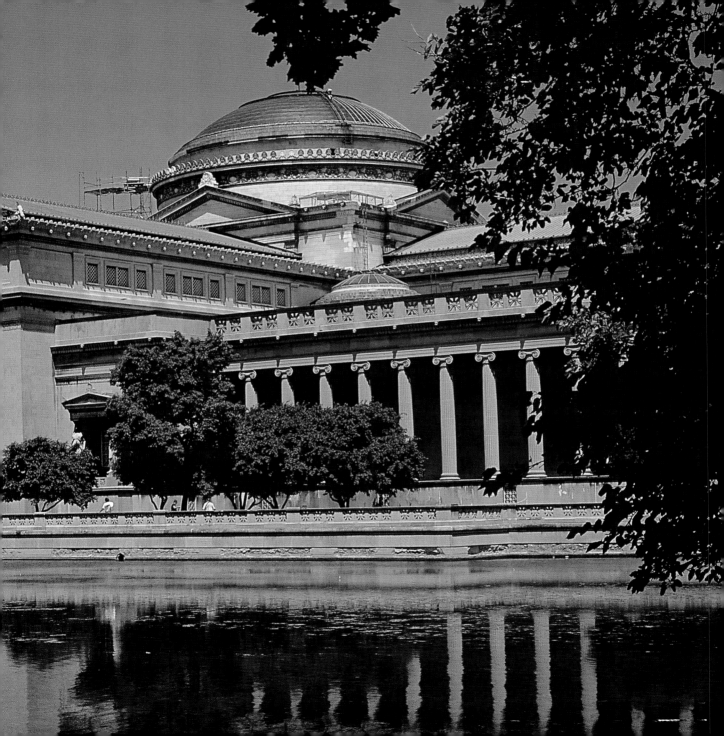

One of four statues by Henry Moore on display in Chicago, *Large Interior Form* is an abstract representation of the human form. Cast in bronze, the sculpture has three holes, which the artist modeled after holes in pebbles he found at the beach.

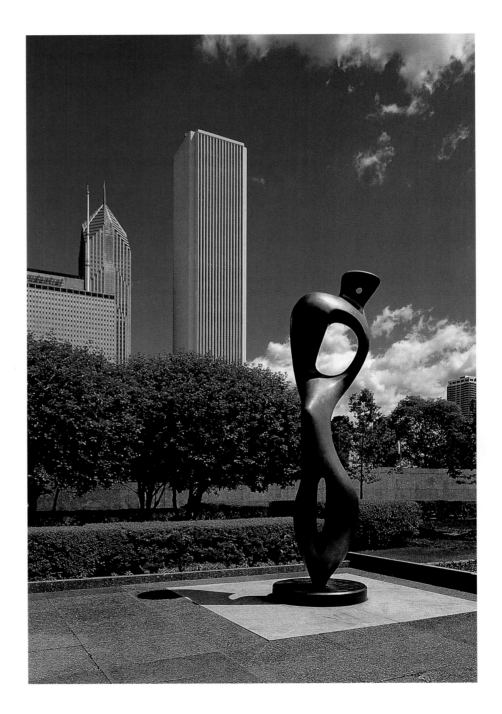

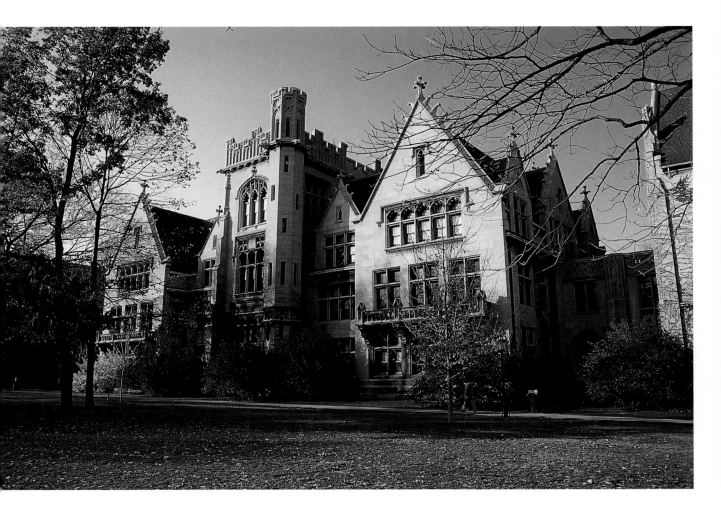

Nobel prizes in physics and economics have been awarded to 12 faculty members of the University of Chicago. The university's accomplishments include the pioneering of carbon-14 dating, the discovery of the jet stream, and the establishment of the first blood bank.

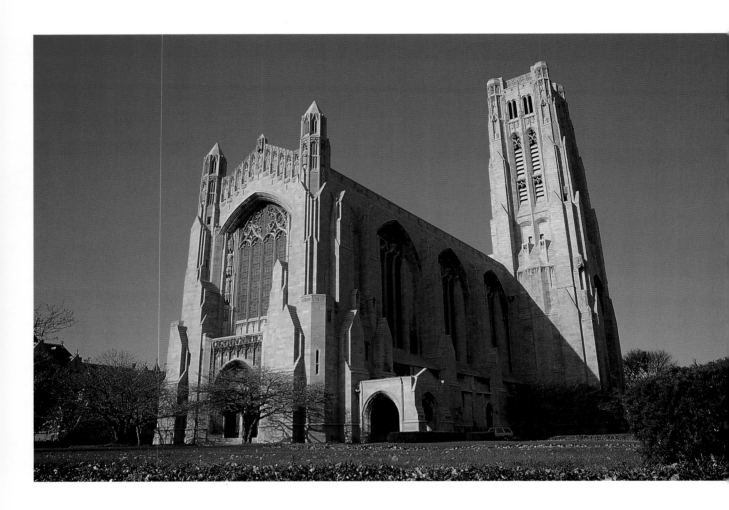

The Rockefeller Memorial Chapel is named for the University of
Chicago's founder, John D. Rockefeller. The chapel is a musical
center as well as a spiritual one—the E. M. Skinner organ and the
Laura Spelman Rockefeller carillon are housed there.

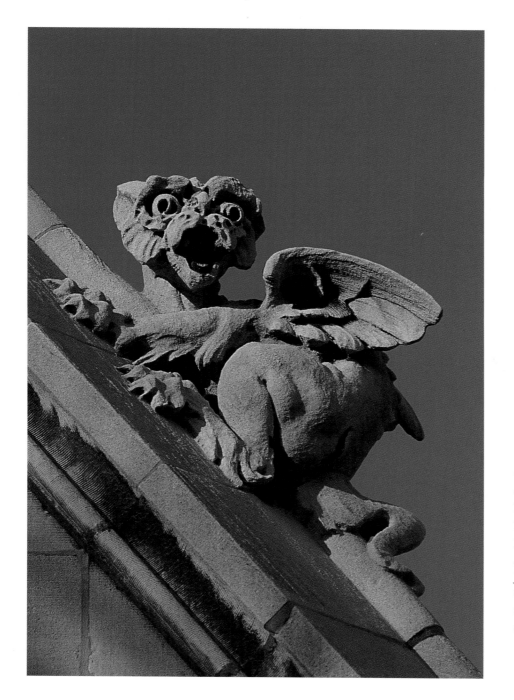

Gargoyles perch on the arches that lead to Rockefeller Memorial Chapel's 207-foot-high roof. At the request of John D. Rockefeller, the chapel remains the tallest building on campus.

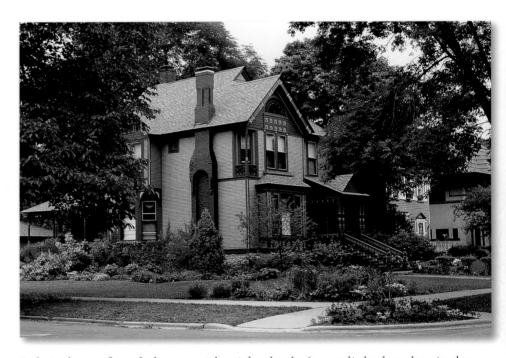

Oak Park was founded as a residential suburb. It was linked to the city by rail in 1848. Though the village quickly expanded and its borders reached Chicago's by the late 1800s, it remained socially and politically distinct.

The Chicago Botanic Garden features 2.3 million plants, 23 individual displays, and areas ranging from an aquatic garden to a children's garden where young visitors can plant their own seeds. Housed on 385 acres, this is one of the most visited botanic gardens in the country.

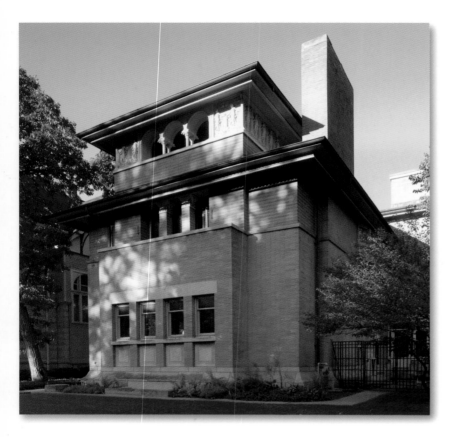

Designed by Frank Lloyd Wright, Heller House represents a turning point
in the architect's shift toward the style that would define his later career,
marked by horizontal lines, flat or hipped roofs, overhanging eaves, and
windows grouped in horizontal bands. Known as a pioneer of the Prairie
style of architecture, Wright believed that buildings should appear as if
they grew naturally from their surroundings.

Two sculptures of a man crouching and breaking free
from the ground beneath him flank the door to Frank
Lloyd Wright's studio. The sculptures were created by
Richard Bock, who collaborated frequently with Wright.

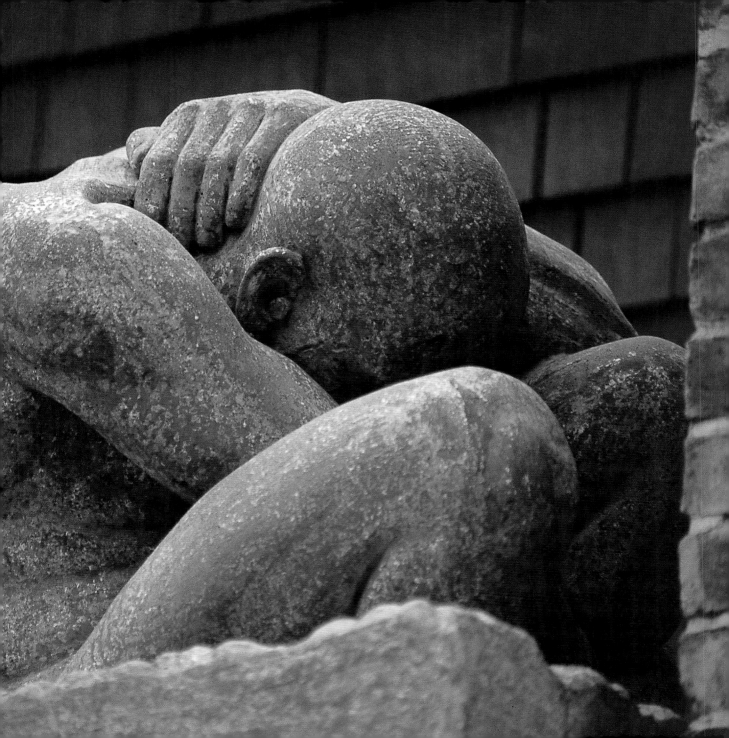

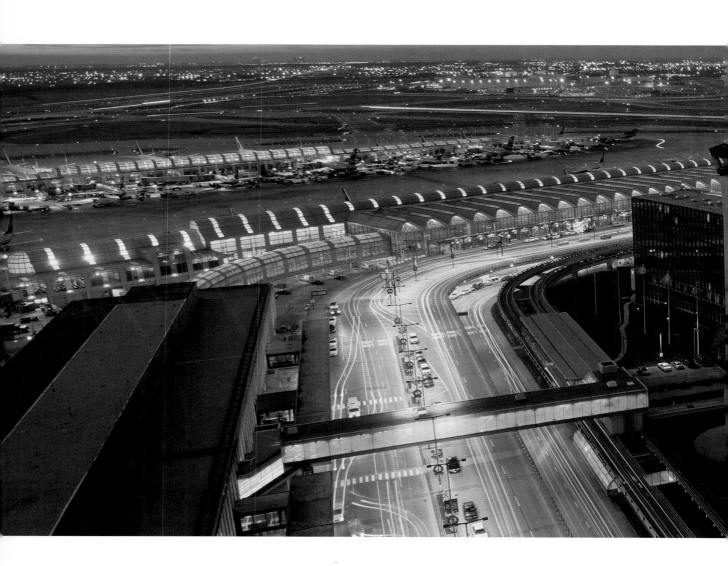

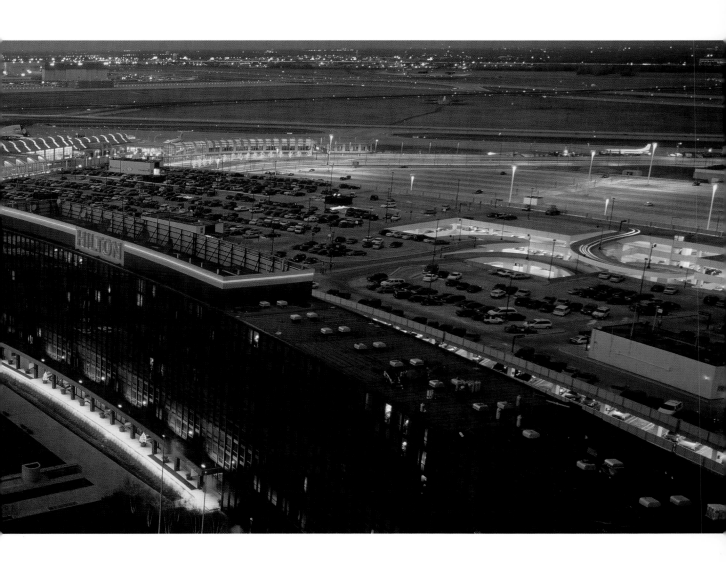

Often voted the best airport in North America, Chicago's O'Hare is also the continent's second busiest. On average, 2,409 flights leave its runways every day.

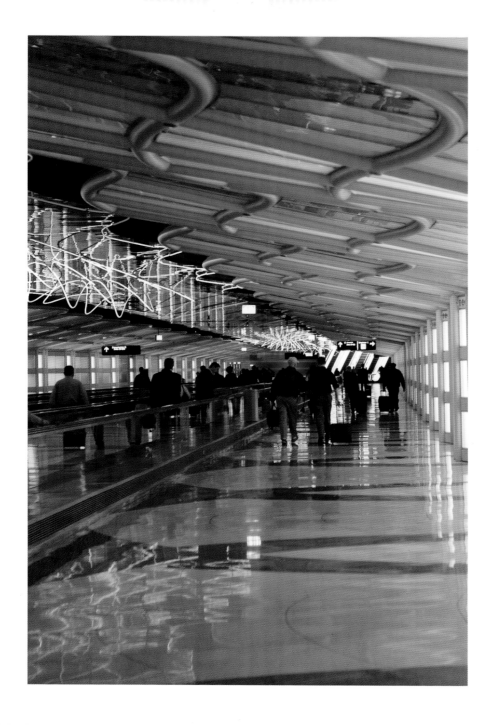

O'Hare International Airport was originally the site of an airplane manufacturing center that provided many of America's cargo planes during World War II. City council acquired the land in 1946 and named the new airport in honor of Edward H. "Butch" O'Hare, a young naval hero killed during the war.

FACING PAGE—
Each year more than 30 million people visit Chicago. The metropolitan area offers over 100,000 hotel rooms, ready to greet guests from around the world.

Billed as "Chicago's other lakefront," Riverwalk is a string of cafés, shops, and attractions framed by 11 of the city's movable span bridges. As part of Chicago's annual St. Patrick's Day celebrations, the Plumber's Union Local 130 dyes the river green.